WHAT
MAKES
GREAT
PHOTOGRAPHY

A Quintessence Book

First published in the UK by
Apple Press
7 Greenland Street
London NW1 0ND
United Kingdom
www.apple-press.com

ISBN: 978-1-84543-453-3
QSS.HPRW

This book was designed and produced by
Quintessence Editions Ltd.
230 City Road, London, EC1V 2TT

| Editor | Becky Gee |
| Designer | Tom Howey |

| Editorial Director | Jane Laing |
| Publisher | Mark Fletcher |

Colour separation by KHL Chromagraphics, Singapore
Printed by 1010 Printing International Limited, China

9 8 7 6 5 4 3 2

FRONT COVER:
Poor Migrant Mother and Children (1936) Dorothea Lange

BACK COVER:
From the series *West Bay* (1996) Martin Parr

Val Williams

WHAT MAKES GREAT PHOTOGRAPHY

80 MASTERPIECES EXPLAINED

APPLE

CONTENTS

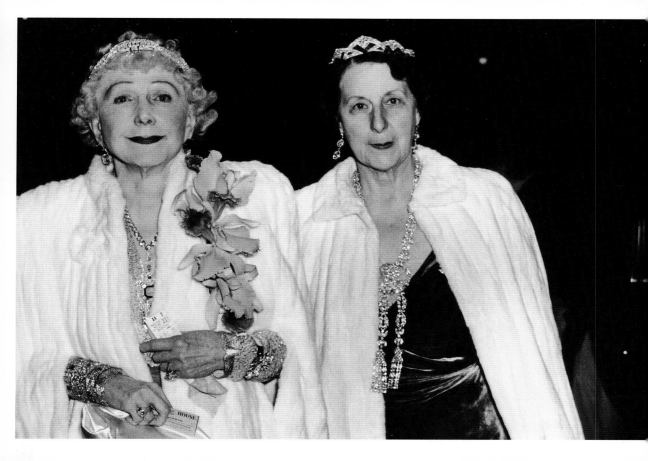

INTRODUCTION

Since the beginnings of photography in the mid-nineteenth century, the medium has made a dramatic impression on how we regard the world. The idea of the "true" likeness of the portrait, which photography was seen to produce, and the evidential photographic documents of people at work, on the streets, at war, at play, and at home were the first signals of a modern world in which everything could, and would, be recorded. In order to be effective, photographs have to attract attention; they have to be well made, using technique to translate vision. All the photographs contained in *What Makes Great Photography* are authored—that is, they were made with the intention of producing an effective image, either for the marketplace of fashion, reportage, or portraiture, or to become part of the poetic vision of a self-directed body of work. In this selection, different values are not assigned to the various categories. The work of fashion photographer Horst P. Horst and press photographer Weegee is as relevant to the discussion about what makes photography work as the art photography of Boris Mikhailov or Sugimoto Hiroshi and the documentary photography of Margaret Bourke-White or Dorothea Lange, for example. All the photographers in this publication produced work that is not only

PREVIOUS PAGE:
The Critic (1943) **Weegee**
≫ THE UNEXPECTED p155

From the series *Västerbotten* (1950s–60s)
Sune Jonsson
≫ HOME p111

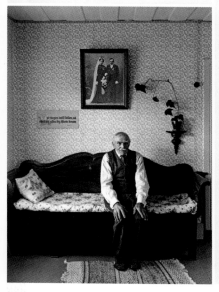

meticulously purposed, but also expands our comprehension of what photography is capable of, and its enduring ability to cross boundaries and blur definitions.

Our appreciation of how and when a single image works is determined by our cultural contexts, by the passing of time, and by our knowledge of the medium of photography. Sune Jonsson's photograph of an elderly man living in the remote rural space of northern Sweden is emblematic of a documentary style that has been central to photography since the 1930s. Other photographs gain cultural significance as time passes: their poetic space is enhanced and deepened; they succeed because we bring to them our own experience and cultural context. If Nicholas Nixon had taken only one photograph of the Brown sisters in 1975, the photograph may have gone unremarked. However, Nixon went on to make a portrait of this group of sisters in the same pose every year, in a continuing series. This repetition brings added resonance to the original photograph; as a single image it works well, but its real power comes from the whole of which it is a part.

Photographs succeed when they open a space for our imagination. Garry Winogrand's image of visitors at a New York zoo, taken in 1969, works on a number of different levels. We are familiar with zoos; they are a part of almost everyone's childhood memories. They are also an in-between

space, a place of transition, and a location for entertainment and spectacle. We come to Winogrand's image with significant memories of childhood, interaction, the exotica of zoo animals, and the thrill of the spectacle. His photograph tells us not about zoos, but about ourselves.

Successful photography is more than the sum of what we bring to it. It is dependent on the ability of the photographer to compose within the frame and to use the equipment that is best suited to the kind of photograph that is being produced. Its success is also to do with angle of vision, interaction with the subject, and, above all, intention. Ansel Adams's photograph, taken in 1948, of sand dunes at sunrise in the Death Valley National Monument, California, is very different from a photograph of the same location that one might find, for example, in a tourist brochure or a book of travel photography. Adams is not informing viewers about the place, but about what photography can do when it confronts place. He knew what kind of photograph he wanted to make before he arrived at the dunes, and he combined careful planning, technology, and vision to make what has become an iconic image of nature in the abstract. Adams did not simply come across the dunes and photograph them; he sought them out, knowing that this particular site could become the conduit for his own philosophies of photography and way of seeing the natural world.

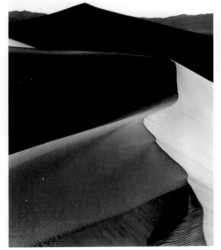

Sand Dunes, Sunrise (1948)
Ansel Adams
⊠ BEAUTY p61

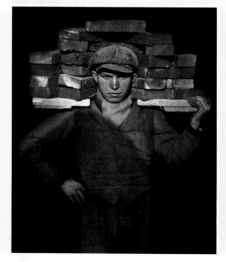

Bricklayer (1928)
August Sander
⊠ WORK p23

Many of the photographs included in *What Makes Great Photography* succeed because the photographers who made them have become absorbed in a community, location, group, or type of people. In the 1920s, August Sander embarked on a project to document German people and their occupations, and he used each of his photographs to represent a type. Thus, his photograph of a young hod carrier taken in 1928 becomes representative of all working men, and an enduring symbol of labor. Sander's photograph was delivered through pose, technique, and point of view, all combining to make a monumental photographic image. Other photographers have produced successful bodies of work because they have become familiar with particular groups of people and have gained the trust and cooperation of their subjects, giving them privileged access. In *Case History* (1997–98), Boris Mikhailov's series about marginalized communities in Ukraine, the photographer worked with the same group of people over an extended period. He photographed his subjects *in extremis* and produced testament about their plight, within which they were collaborative partners. The New York photographer Tina Barney photographed within the intimate group of her family and its extended friendships, and her subjects, in turn, became part of the collaborative process. Likewise, the West Coast photographer Larry Sultan, working with

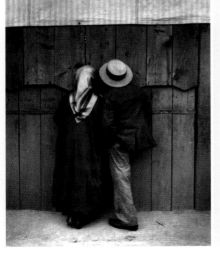

Circus, Budapest (1920)
André Kertész
⏩ STORY p35

his immediate family to explore memory and shared histories, was given unlimited access to domestic life and, with his parents, became part of a decade-long exploratory process recorded through photography.

In documentary and reportage photography, this sense of belonging and the collaborative process can become less necessary. Paul Graham's series of photographs made in unemployment offices in Britain during the 1980s was taken surreptitiously, and the photographs succeed, partly, because of this. His personal, critical point of view is emphasized by the askew angles from which the photographs were taken, as the camera became a covert tool of investigation. The success of Ian Berry's photograph of a visitor to the Chelsea Flower Show, made in the 1970s, depends very much on Berry's training as a photojournalist: the ability to identify a situation, compose quickly within the frame, and capitalize on the surprise of his subject. This methodology—as used by André Kertész in his photograph taken in 1920 of a couple spying through a wall around a circus tent in Budapest, by Bill Brandt in his image of tic-tac men at Ascot in 1935, and by Robert Capa in 1936 in his photograph of passersby watching German planes flying overhead in Bilbao—is one of gathering, encountering, and recording fleeting events and situations, and it is central to both photojournalism and diaristic documentary photography.

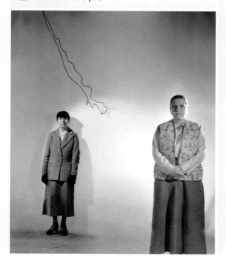

Gertrude Stein and Alice B. Toklas
(1936) **Cecil Beaton**
⊠ RELATIONSHIPS p73

When photographers decide to make portraits, they have a different set of considerations. Cecil Beaton's photograph of Gertrude Stein and Alice B. Toklas, made in Paris in 1936, depended very much on Beaton's own knowledge of the couple and what they represented in contemporary culture, as well as his own innate sense of the absurd. To this portrait, Beaton brought not only his extensive knowledge of lighting, pose, and costume, but also an appreciation of Stein and Toklas's standing as avant-garde cultural personalities. He knew that the women would be both monumental and exotic as subjects—his task in the series of portraits that he took was to produce photographs that conveyed both the status and idiosyncrasy of Stein and Toklas, and that would inform an audience that was not necessarily intimate with avant-garde Europe. Like many innovative photographers of his generation, Beaton used the studio to construct a setting around his subjects. By including a contorted piece of wire in the eventual portrait, Beaton was able to introduce dissonance and tension into a stark and simple studio set.

Photographs also succeed because photographers push the medium beyond set boundaries. In his photograph of gold miners taken in Brazil in 1986, Sebastião Salgado produced an image that has more affinity with the epic scale of the film set than it does with the reportage practice from which

Salgado emerged. In her series of photographs of the boardroom tables of the world's forty leading companies titled *The Table of Power* (1993–95), Jacqueline Hassink reinterprets the studied banality of the corporate photograph in order to express her interest in the luxuriously bleak interiors of the business meeting place; through photographs she makes a series of maps of power and influence, seen through ranks of empty chairs and giant tables. The artist Cindy Sherman, in her *Untitled Film Stills* series from the 1970s, constructs photographs that appear to sit in a culture of postwar celebrity, but that both subvert and celebrate the notion of performance.

An important element in our exploration of what makes photographs work is the presence of an audience. All the photographs included in this publication were made with an audience in mind; some were actively commissioned. When Dorothea Lange and Walker Evans made documentary photographs for the Farm Security Administration in the mid-1930s, they knew that the photographs were a tool of social politics, intended to educate the public and politicians about the challenges of rural deprivation in Dust Bowl America. Likewise, Lee Miller knew that her postwar photographs of the aftermath of war and the Holocaust would appear in *Vogue* magazine, whose readers would have been fine-tuned to the best of contemporary fashion photography. The photograph of a dead

Dead SS Guard Floating in Canal, Dachau (1945) **Lee Miller**
▷ CONFLICT p127

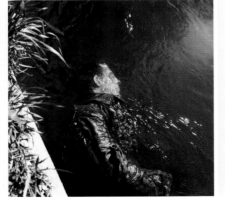

German soldier included in this selection is highly aestheticized—death as poetic—whereas Margaret Bourke-White, photographing conditions at the end of Nazi rule for *Life* magazine, would have been aware that her audience would expect hard-hitting reportage.

Photography is truly successful when it fulfills its purpose, whether the image is destined for the gallery, magazine page, or monograph. Eric Hosking produced a monumental photograph of a barn owl in 1948, not as a work of art but as an informative image for naturalists. Horst P. Horst's *Goya Fashion* (1940) was aimed directly at a metropolitan elite, who would have been well aware of art historical references and who appreciated the seriousness of high fashion. Taken in the northwest of England in 1985, Martin Parr's photograph of a young woman serving fast food is part of a personal documentary series, and it was aimed at the photographic and media community via publication in a limited edition monograph.

A photograph succeeds most of all when we remember it, when we give it space in our stored visual recollections. Most of the photographs in *What Makes Great Photography* are well-known images that have been central to the making of the history of photography in Europe and the United States. They are "remembered" in a number of different ways:

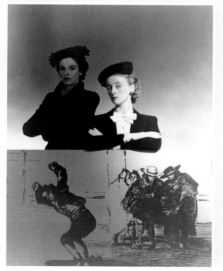

Goya Fashion (1940)
Horst P. Horst
⊠ THE UNEXPECTED p153

through publication and by being collected, exhibited, and discussed. They are images that have survived and endured, acquiring numerous layers of meaning as they age, but with their central purpose and core intact. They become symbolic of time and place: when we think of the Dust Bowl in the United States, a photograph by Walker Evans or Dorothea Lange will come to mind. When we reflect on the tragedies of war and conflict, the work of photojournalists such as Margaret Bourke-White and Robert Capa is part of our visual store of memories. Sune Jonsson and Esko Männikkö's photographs of people living in rural Scandinavia remain firmly fixed as universal symbols of social and physical isolation; they transcend location and become universal.

Photography works when we know and remember it; when it yields detail and information about who, and how, we are; when it gives us space to reflect and imagine, and to construct our own narratives.

It takes us to the heart of the matter.

Val Williams

Val Williams

Interior of Coal Miner's Home, West Virginia (1935) **Walker Evans**
⏵⏵ HOME p109

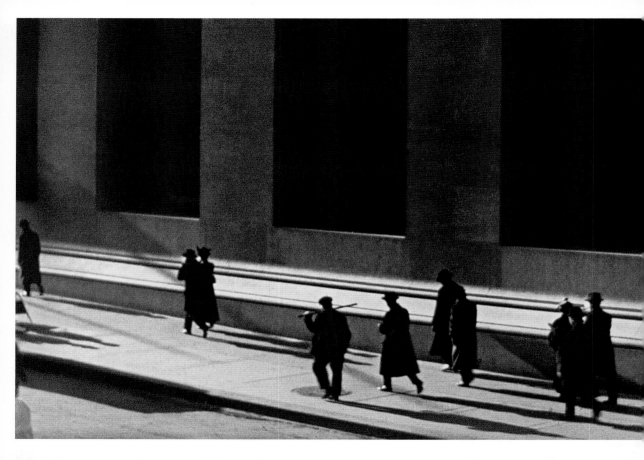

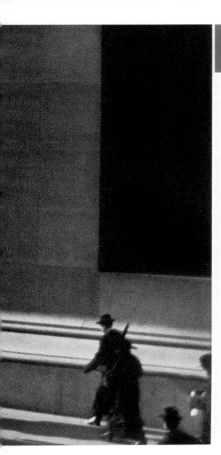

WORK

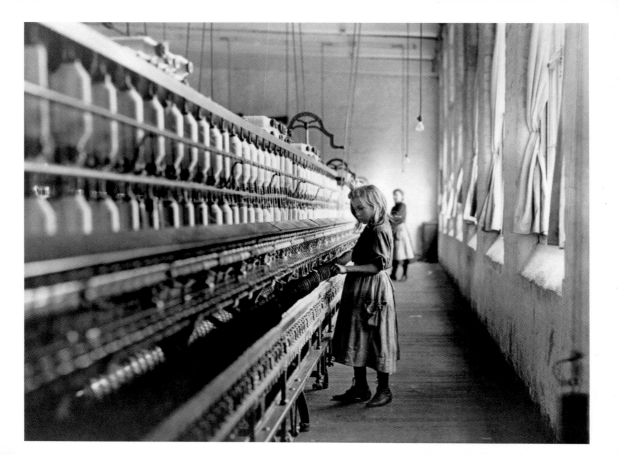

Textile Mill, USA 1908
Lewis Hine

Hine's photograph was intended to educate the public about child labor. He emphasizes the smallness of the child by photographing her from a distance, dwarfed by the machinery. The long line of reels introduces the idea of repetitive work and the fact that the child is trapped in an endless mechanical process. Hine contrasts the fragility and humanity of the child with the linearity and scale of the industrial interior and thus establishes a central conflict within the image. The child is far away from her nearest workmate, unable to communicate. She stands with her back to the daylight and her body droops.

This image of a child working in a Carolina cotton mill was made by Lewis Hine for the National Child Labor Committee. He was committed to photography as a tool for social change, and, after photographing working conditions in the steel towns of Pittsburgh, he began to make documentary images of working children's lives. His photographs were intended not only to encourage social action and reform, but also to record working conditions. The impact of this image is intensified by the skillful use of contrast and contradiction, and it remains as powerful today as it was at the beginning of the twentieth century.

There are two things I wanted to do. I wanted to show the things that had to be corrected. I wanted to show the things that had to be appreciated."

Lewis Hine

Gelatin silver print
Lewis Hine Collection,
Library of Congress,
Washington, D.C., USA

Textile Factory, Moscow (1954)
Henri Cartier-Bresson

Rubbish Dump, Smokey Mountain, Manila (1988)
Stuart Franklin

Child With Star Mask, El Salvador (1992)
Larry Towell

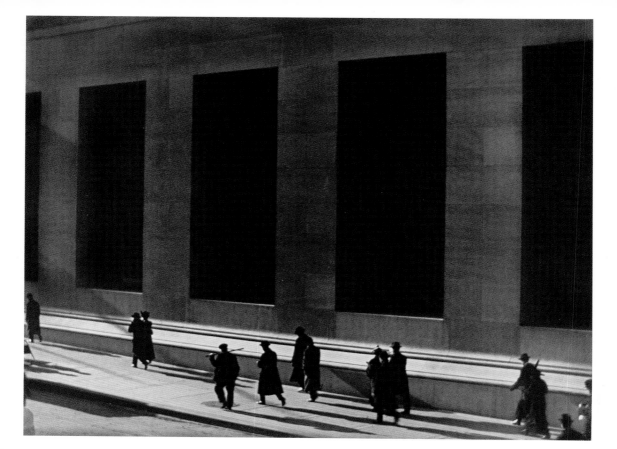

Wall Street 1915
Paul Strand

The making of *Wall Street* was planned meticulously. Strand positioned himself on the top of the Treasury steps to make a cityscape that would capture "the abstract movement of the counterpoint between the parade of those great black shapes of the building and all those people hurrying below." The photograph presents New York not only as a site of movement and dynamism, but also as a city in which the commercial imperative dwarfs its population, where buildings soar toward the sky, and people scurry through the shadows to work.

Paul Strand was one of a grouping of early US modernist photographers whose photographs define a nation in a period of rapid change. One of Lewis Hine's students at the Ethical Culture School in New York, he was acutely aware of the value of photography as a social educator. *Wall Street* explores, with cool precision, a society in flux, confronting and embracing modernity. Originally titled *Pedestrians Raked by Morning Light in a Canyon of Commerce*, the photograph is dominated by the row of huge black rectangular recesses that impart a sense of foreboding to an otherwise routine scene of businesspeople on their way to work.

I was trying to re-create the abstract movement of people moving in a city; what that kind of movement feels like and is like."

Paul Strand

Platinum print
San Francisco Museum
of Modern Art, California, USA

The City (1939)
Willard van Dyke
Museum of Modern Art,
New York, USA

Sao Paolo, Brazil (1960)
René Burri

*Workers Leaving at the End
of the Day, Michigan, USA* (1981)
Bob Adelman

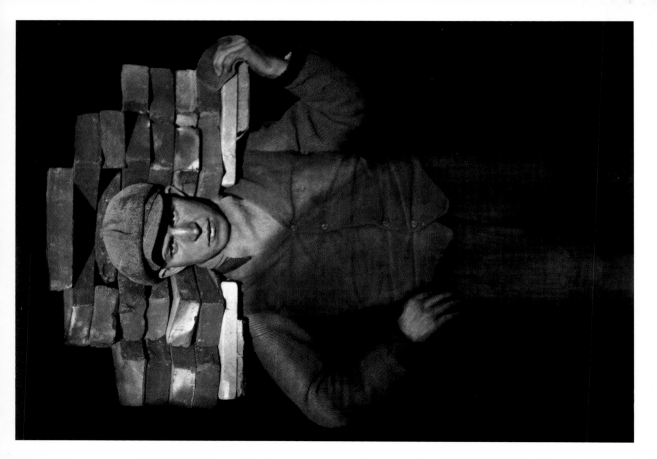

Bricklayer 1928
August Sander

Sander's admiration of the strength and directness of this bricklayer is clear, and it becomes the major piece of emotional information in this image. The bricks appear impossibly heavy, yet the young man balances them on his shoulder as if they were gossamer. The dark background and the shaft of light, which cuts diagonally across the man's face and body, give this photograph a magical and ethereal appearance, in sharp contrast to the rough irregularity of the bricks. Although it was not Sander's intention to show the bricklayer at work, the image gives viewers precise information about that work and the strength and vigor needed to do it. In other portraits in the series, such as those of farmers, lawyers, and artists, Sander reveals the profession and class of his sitter through their gesture, clothing, and setting.

August Sander's photograph of a young bricklayer, made in the city of Cologne at the end of the 1920s, is from the series *People of the Twentieth Century*. By the time he began the series, Sander was an experienced photographer and was well aware of the importance of pose, composition, and lighting. He created many hundreds of photographs for this collection, which has endured as an important example of the significance of descriptive portraiture. Although he was interested in photographing and documenting "types," Sander was also aware of the individuality of each of his subjects. In *Bricklayer* he portrays a handsome and athletic young man, who poses gracefully for the camera and fixes the viewer with his steady gaze.

❝ *Nothing is more abhorrent to me than sugary-sweet photography full of pretence, poses, and gimmickry. For this reason, I have allowed myself to tell the truth about our times and people in a sincere manner.*"

August Sander

Gelatin silver print
Die Photographische
Sammlung/SK Stiftung Kultur,
Cologne, Germany

Delivering Coal (c.1916)
Horace Nicholls
Royal Photographic Society,
Bath, UK

Powerhouse Mechanic (1920)
Lewis Hine

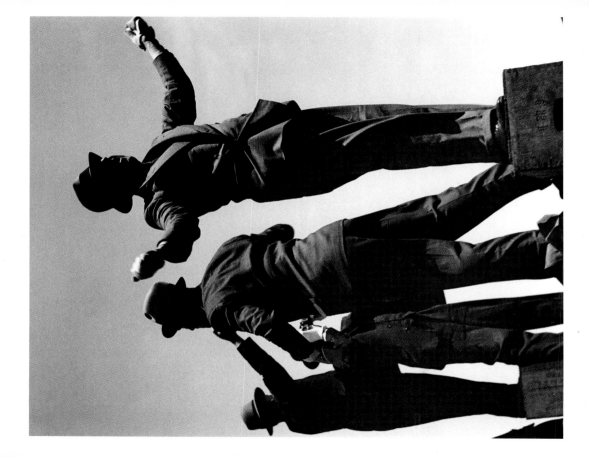

Tic-Tac Men at Ascot Races 1935
Bill Brandt

Brandt's gesturing bookmakers are seen as statues: each caught in mid-gesture, they stand like preachers, imploring the faithful. The photograph succeeds because Brandt caught a remarkable moment of arrested movement and stilled time. He photographs the bookmakers from below, so that they are silhouetted against the sky. It is as if they are quite alone, locked into a mysterious brotherhood. With their almost identical suits, the tic-tac men become like characters in a chorus, Cassandras forecasting the future.

Tic-Tac Men at Ascot Races is one of the most effective photographs in the history of photography, and it first appeared in *The English at Home*, published in 1936, under the title *Bookmaker's Signals*. The image is a depiction of ordinary working life made monumental, and central to its success is the way in which British photographer Bill Brandt captured the grace and vigor of the workers' gestures. Produced with a Rolleiflex camera using 2/14 square negative film, it combines precise detail with documentary fluidity to produce a snapshot of British society. The resulting photograph is both mysterious and moving.

> *A photographer must be prepared to catch and hold onto those elements which give distinction to the subject or lend it atmosphere. They are often momentary, chance-sent things. . . .*
>
> **Bill Brandt**

Gelatin silver print
Museum of Modern Art,
New York, USA

*Bijou au Bar de la Lune,
Montmartre* (c.1932)
Brassaï

"Girl About to Do a Handstand"
from the series *Southam
Street* (1957)
Roger Mayne

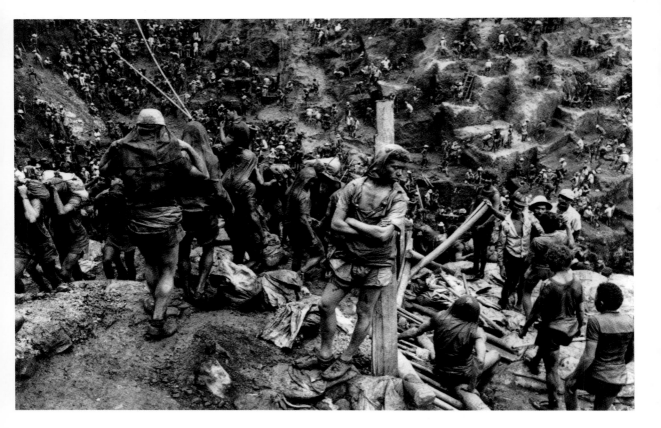

Gold Mines of Serra Pelado, Brazil 1986
Sebastião Salgado

Salgado's photojournalism is highly dramatic, using form, texture, and mass to make photographs that give everyday scenes epic proportions. This photograph relies on Salgado's ability to create narrative from real life: the men that he photographs move as a fluid crowd across a hillside of mud, all absorbed in their labors, except for the central figure in the image. This man leans against a post, arms folded, head to one side, oblivious to his fellow workers. While the mass of workers is anonymous—only a few faces can be seen—this central figure emerges as an individual, graceful and enigmatic.

This photograph is one of the early images in Sebastião Salgado's *Workers* series, which has become one of contemporary photography's most acclaimed bodies of work. The series created a new aesthetic in photojournalistic practice: lush, dramatic, and highly narrativized. Salgado became a photojournalist in the early 1970s, and *Workers* debated political and social issues about labor in the developing world. He constructs this image around a powerful focal point, creating drama and monumentality.

> *What I want is to create a discussion about what is happening around the world and to provoke some debate with these pictures. Nothing more than this."*
> **Sebastião Salgado**

Photographer's collection

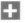
The Great Chartist Meeting on Kennington Common (1848)
W. E. Kilburn
Windsor Castle, Windsor, UK

Breaker Boys in a Coal Mine (1911)
Lewis Hine

Construction Site of the Fergana Grand Canal (1939)
Max Alpert

From the series *The Table of Power* 1994
Jacqueline Hassink

The Table of Power series (1993–95) explores the world of corporate might and economic power, as in the "Nestlé" image (left). In the main image, the Daimler Benz table is lit by daylight entering from a window and from above, and by spotlights near the ceiling. The neutral colors of the objects and surfaces—chairs, table, carpet, and walls—are interrupted by the composition of brightly colored images of cars on the wall. In Hassink's photograph, the huge table and its circle of identical chairs seem to float in a lake of corporate beige. Quiet and solid, it waits for the powerful men and women who will occupy it.

This photograph shows the meeting table of the board of directors of Daimler Benz in Stuttgart. Jacqueline Hassink became interested in these "tables of power" in the early 1990s; she was fascinated by the wealth and corporate influence they represented, and by photographing them in empty rooms she emphasized their size and magnificence. The project is characterized by meticulous research into multinational companies and contemporary corporate life. Before she made the series, Hassink embarked on a complex process of seeking permission and access, a vital part of methodology when artists photograph private, highly protected spaces.

I'm interested in spaces, in the psychology of rooms. It's quite fascinating to look around in the office of a powerful CEO."
Jacqueline Hassink

Cibachrome print
Amador Gallery,
New York, USA

Meeting of the Board of Directors Villa Hügel, Essen (1961)
René Burri

Prime Minister's Meeting Room (1992)
Raymond Depardon

Inside the Masonic Lodge Headquarters (2001)
Martin Parr

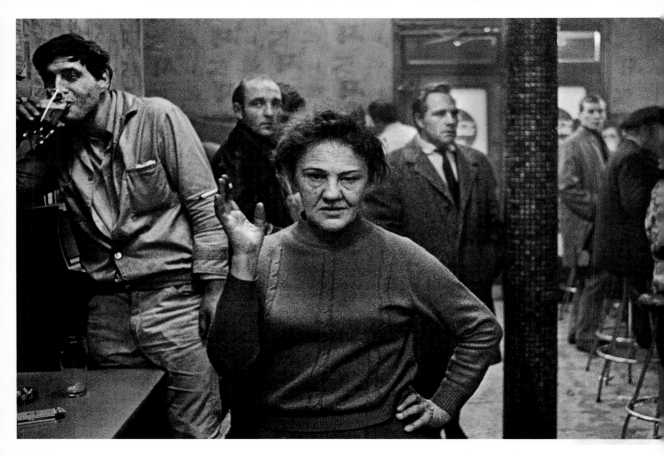

STORY

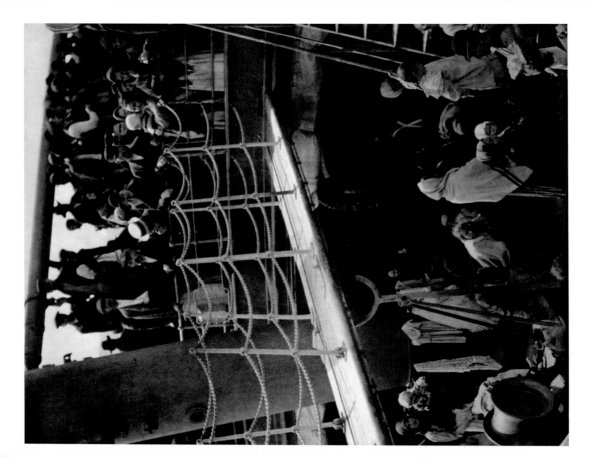

The Steerage 1907
Alfred Stieglitz

The Steerage is divided into two distinct sections, bisected by a plank and rope bridge. Three diagonals, made by a funnel, a mast, and a ladder, enclose the photograph within the frame, and introduce a tension into the image that gives it dynamism and force. The photograph marks a shift in Stieglitz's work from pictorialism toward modernism, heralding a new direction for photography. The image was not published until 1911, in the magazine Camera Work, and it was part of an entire issue devoted to Stieglitz's work.

Alfred Stieglitz was a pioneering member of early twentieth-century New York photographic circles, and his influence on the progressions of photography, from painterly construct to modernist clarity, was immense. The Steerage illustrates how Stieglitz combined documentary observation with a deep concern for composition and form. He made the photograph while he was traveling on the SS Kaiser Wilhelm II from New York to Paris. The tight framing highlights the animated scene on the steerage deck of the steamer, as the lower-class passengers interact at close quarters.

> I saw shapes related to one another—a picture of shapes, and underlying it, a new vision that held me: simple people: the feeling of the ship, ocean, sky."
>
> **Alfred Stieglitz**

Photogravure on vellum
Whitney Museum of American
Art, New York, USA

Street Scene With a Woman
(1931) **Florence Henri**
National Gallery of Australia,
Canberra, Australia

Behind the Gare St. Lazare
(1932) **Henri Cartier-Bresson**
Museum of Modern Art,
New York, USA

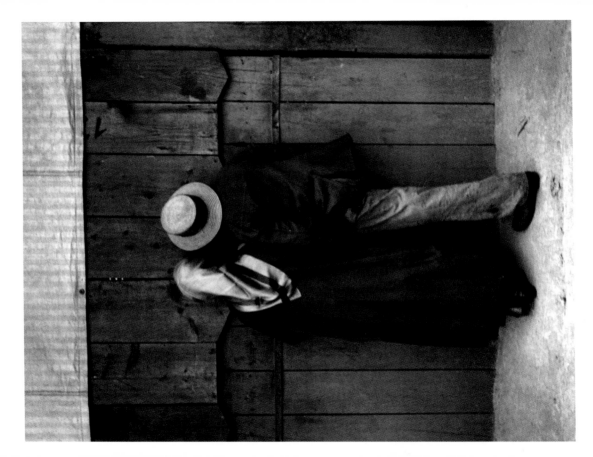

Circus, Budapest 1920
André Kertész

During his wanderings around Budapest, Kertész chanced upon this situation and used his photographer's eye to frame the photograph with great accuracy. Split into horizontal sections of wood, cloth, and grass—and bisected vertically by the man and woman, standing close together—the photograph has great symmetry and form. The lines of the wood and cloth are emphasized by the garments and hats worn by the couple, which—free formed and textured—are in relief against the vertical lines of wooden planking.

André Kertész's photograph of a couple peering through an opening in the wall of a circus enclosure has all the mystery of the best of street documentary. The couple are unaware of the photographer's presence and are so fascinated by events behind the fence that we can almost see this hidden scene. There is an event beyond the photograph we see, but Kertész is content to tell this simple story of curiosity and concentration. He demonstrates what can be achieved by acute observation and photographs made at speed.

[For me, the camera was] a little notebook, a sketchbook.

I photographed things that surrounded me—human things, animals, my home, the shadows, peasants, the life around me. I always photographed what the moment told me."

André Kertész

Gelatin silver print
Stephen Bulger Gallery,
Toronto, Canada

Three Boys at Lake Tanganyika (1930)
Martin Munkácsi

Fox Terrier on the Pont des Arts (1953)
Robert Doisneau

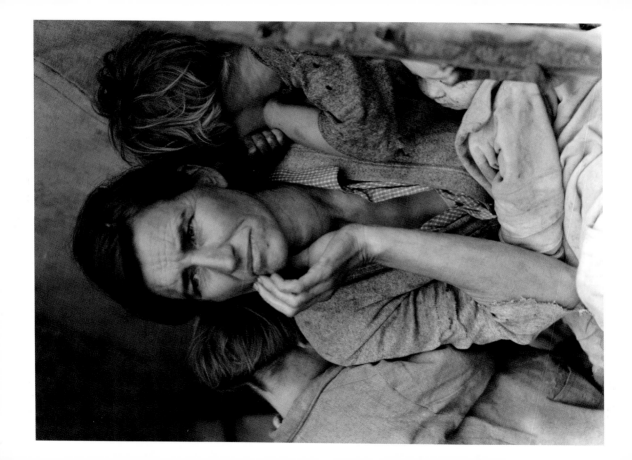

Migrant Family 1936
Dorothea Lange

Lange made six exposures of Owens holding an infant, with two of her children standing on either side of her, heads bowed, faces averted from the camera. This close-up focuses attention on the passive demeanor of the poorly dressed, prematurely aged woman, gazing pensively away from the camera. In fact, everyone in the photograph is passive, submitting to the camera. The construction of the photograph, with a child on either side of Owens, has a powerful symmetry—a Madonna flanked by cherubs, bedraggled by poverty.

Better known as *Migrant Mother*, this image is a portrait of Florence Owens Thompson and her children, made at a pea pickers camp at Nipomo, California. Dorothea Lange pictures the family as both resilient and vulnerable. She saw her photography as "a tool of research," and this image was made during a field trip for the Resettlement Administration. It brought the plight of migrant workers and the extent of rural poverty to public attention. However, controversy surrounds the photograph because it was published after Lange had assured Owens that it would be used for research purposes only.

While there is perhaps a province in which the photograph can tell us nothing more than what we see with our own eyes, there is another in which it proves to us how little our eyes permit us to see."

Dorothea Lange

Gelatin silver print
Library of Congress,
Washington, D.C., USA

Sharecropper's Family, Alabama (1936) **Walker Evans**
Metropolitan Museum of Art,
New York, USA

Immigrants Arriving at Sha'ar Ha'aliyah, Haifa, Israel (1948)
Robert Capa

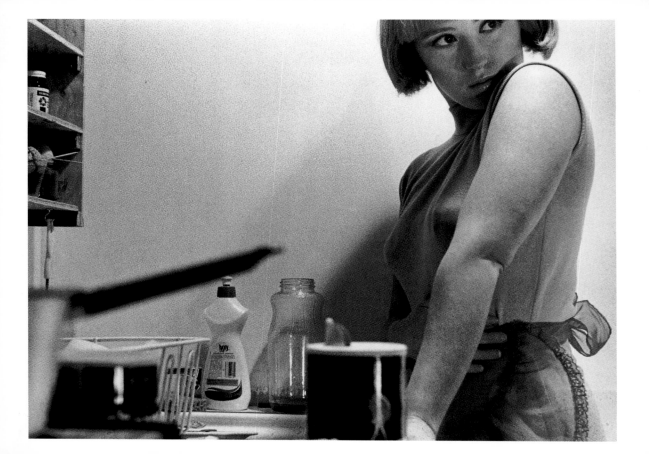

Untitled Film Still, No. 3 1977
Cindy Sherman

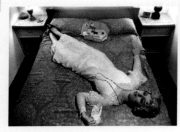

Many of the sixty-nine photographs in the series were taken in the photographer's apartment and were styled and directed by Sherman ("No. 11," 1978; left). She was fascinated by dressing up and assuming alternative personae, and as the subject of her photographs, she becomes the central character in each story. The *Untitled Film Stills* series is central to the history of modern photography. The pose and dress of the woman at the kitchen sink in *Untitled Film Still, No. 3* is clearly drawn from US consumerist advertising and becomes a social comment about women's place within consumerist society.

New York artist Cindy Sherman began her series *Untitled Film Stills* in 1977, and "No. 3" is a photograph of a young woman poised over a kitchen sink. Although her pose is assertive, she glances away from her domestic task, staring at some out-of-frame scene, object, or person. Sherman immediately sets up a tension in the photograph: the woman's hand is placed across her waist—defensive and unsure—but the angle of her arm, seen in full in the foreground, is assertive and uncompromising.

I think of becoming a different person. I look into a mirror next to the camera . . . it's trancelike. By staring into it I try to become that character through the lens. . . . When I see what I want, my intuition takes over."
Cindy Sherman

Gelatin silver print
Museum of Modern Art,
New York, USA

The Elopement (1862)
Lewis Carroll

*Untitled (I Am in Training,
Don't Kiss Me)* (c.1927)
Claude Cahun Jersey Museum
and Art Gallery, St. Helier, UK

"Star Struck" from the series
Chameleon (1974–75) **Judith
Golden** Larry N. Deutsch Collection,
Chicago, Illinois, USA

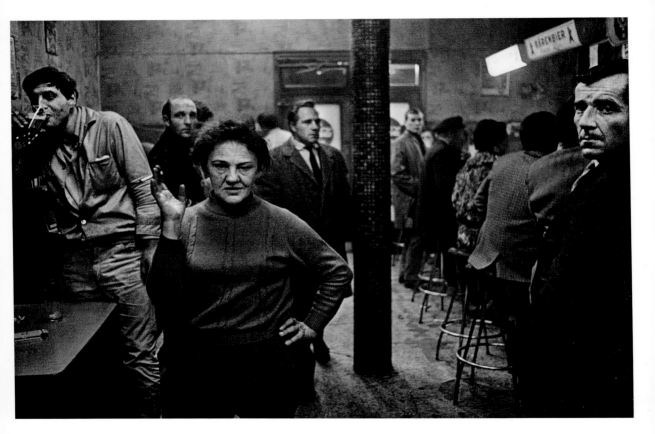

Café Lehmitz 1978
Anders Petersen

For Petersen, the enclosed space of the café was important; it enabled him to portray the intimacy of the relationships between the café's clients, and to place himself in close proximity to the men and women he photographed over an extensive period of time. This image shows a woman staring directly at the camera. Some of the customers look over, but most sit with their backs to the photographer. Although the central focus of interest is the woman, Petersen captures all the elements of the scene—from the café's décor to the crowd of customers—to make an image full of activity and interest.

Anders Petersen's collection of photographs of a late-night bar has rightfully maintained its status as one of the most powerful series of documentary photographs made in the 1970s. Café Lehmitz was situated in the St. Pauli district of Hamburg, and although the area had a certain notoriety and the bar attracted a colorful clientele, for Petersen, Café Lehmitz became a familiar place, where he was known and welcomed. His photographs tell the intimate and sometimes graphic stories of those who frequented the bar, members of a close-knit community.

> *[This series is] a kind of family album. After a while, going around and staying there, being with them, having a good time with them, I felt almost part of the family."*
>
> **Anders Petersen**

 Photographer's collection

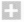 *Lovers in a Café* (1932)
Brassaï

Café Noir et Blanc (1948)
Robert Doisneau

Café Terrace, Paris (1962)
William Klein

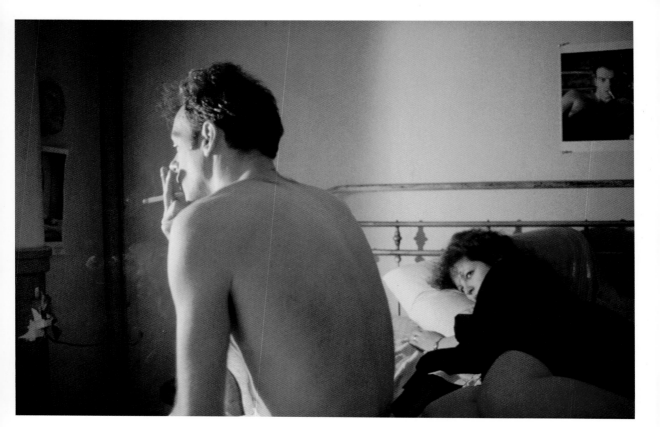

Nan and Brian in Bed 1983
Nan Goldin

Goldin constructs an intimate, enigmatic tableau to tell this story. The photograph is open to a range of interpretations, and its lack of literalness has made it one of the great contemporary images, as photography entered a period of experimentation in the early 1980s. "Nan and Brian in Bed" is about a moment: two people together, as lovers, yet isolated from each other. Attention focuses on the two figures: Goldin stares at her lover, who smokes a cigarette and stares out of the window. The power of the photograph lies in its mystery, and photography keeps the secret.

From the series *The Ballad of Sexual Dependency,* "Nan and Brian in Bed" is one of 800 photographs assembled by Nan Goldin as an audio visual production and, in edited form, as a book. The series is a narrative portrait of Goldin's subcultural, bohemian circle. She refers to her photographs as "snapshots," and the images represent the ultimate alternative family album. Goldin refers to *Ballad* as "the diary I let people read," and the photographs—casual and opportunistic—are a carefully constructed chronicle of love, excess, drama, vanity, and friendship, enacted against the backdrop of 1980s New York.

> *My desire is to preserve the sense of people's lives, to endow them with the strength and beauty I see in them. I want the people in my pictures to stare back."*
> **Nan Goldin**

Silver dye bleach print
Metropolitan Musem of Art,
New York, USA

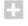

Gillian and Christopher in Doorway (1991)
Wolfgang Tillmans

The Necklace (1999)
Alessandra Sanguinetti

Raquel Zimmermann and Charlotte Rampling in the Louvre (2009)
Juergen Teller

43

Gdansk, from the series *The Sound of Two Songs* 2004
Mark Power

For Power, this photograph was partly a response to the Holocaust, an important and problematic piece of Poland's history. He noted: "I knew I wanted to deal with this in some way, but without offering pictures of the camps. And then, while in the shipyard in Gdansk, I happened upon a pile of gray tubes, neatly swept into a corner. It reminded me of the piles of spectacles, shoes, or hair that you see in the Auschwitz Museum. And even if you haven't seen the real thing you would surely know the photographs. So my picture of those tubes became my picture about the Holocaust."

Mark Power began to photograph in Poland in 2004 as part of a commission awarded to Magnum photographers, and he soon became intrigued by the derelict industrial structures, bleak townscapes, and a society in flux. Power's images are highly detailed and have enormous clarity. Like many of the photographs in the series, "Gdansk" is a monumental vision of an unremarkable detail. In the photograph, Power's color palette is a somber combination of grays. The tubes in the corner of this industrial building are piled high and seemingly abandoned, but they also have a reptilian quality, like a mountain of truncated giant worms silently writhing.

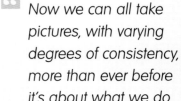

Now we can all take pictures, with varying degrees of consistency, more than ever before it's about what we do with photography."
Mark Power

Digital c-type print
Photographer's collection

Sea of Tears (1939)
Manuel Alvarez Bravo
J. Paul Getty Museum,
Los Angeles, California, USA

I Will Take Revenge! (1943)
Georgy Khomzor
Museum of Modern Art,
New York, USA

Barbed Wire, Poland (1958)
Josef Koudelka

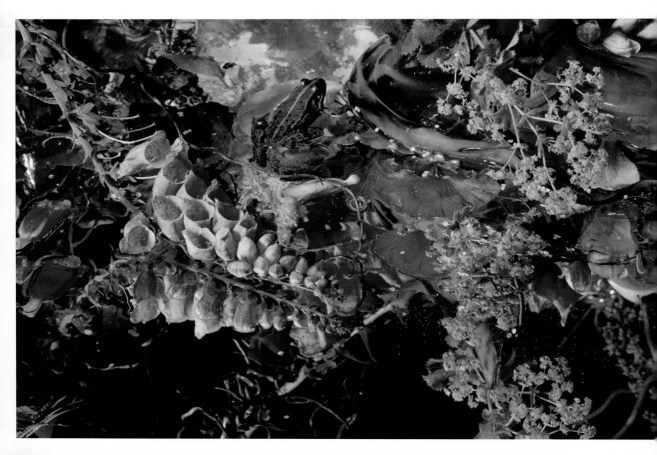

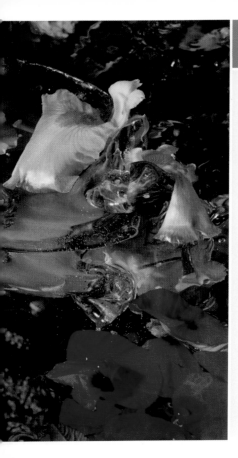

BEAUTY

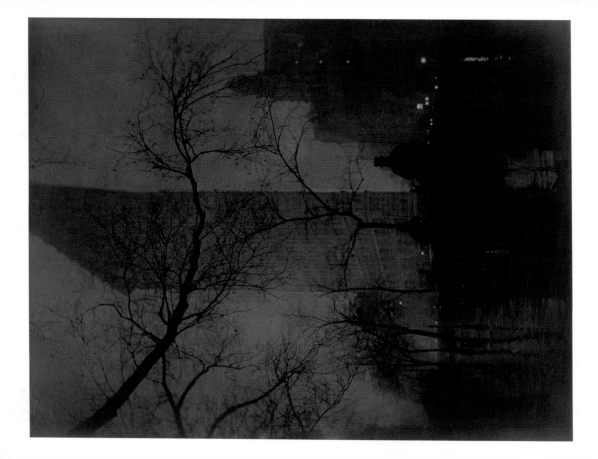

The Flatiron · 1904
Edward Steichen

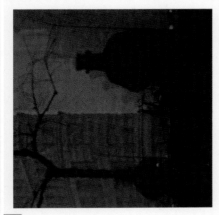

In this photograph Steichen created a vision of New York that belied the city's modernity and brashness, setting the scene as one of beauty and romance. He softened the severity of architecture by photographing the Flatiron Building at twilight through a latticework of winter trees. In the foreground, carriages wait and lights glimmer through the mist of rain. The image resembles James McNeill Whistler's *Nocturnes* series in the way that it portrays the coloristic effects of light.

Edward Steichen captured the height of romanticism in the painterly pictorialist tradition. That photographs should look like paintings was a central part of pictorialist thinking, as art photographers sought to move away from commercial photography and establish the medium as a fine art. Daniel Burnham's remarkable Flatiron Building was completed two years before this photograph was taken, and Steichen's pictorialist vision was put to the test as he confronted this distinguished symbol of the new modernity. The platinum print was made colored by using an overlayer of color pigment suspended in gum bichromate.

> " Photography records the gamut of feelings written on the human face, the beauty of the earth and skies that man has inherited, and the wealth and confusion man has created."
>
> **Edward Steichen**

Platinum print
Metropolitan Museum of Art,
New York, USA

Reflections, New York (1896)
Alfred Stieglitz
George Eastman House,
Rochester, New York, USA

Broadway at Night (1910)
Alvin Langdon Coburn
The Phillips Collection,
Washington, D.C., USA

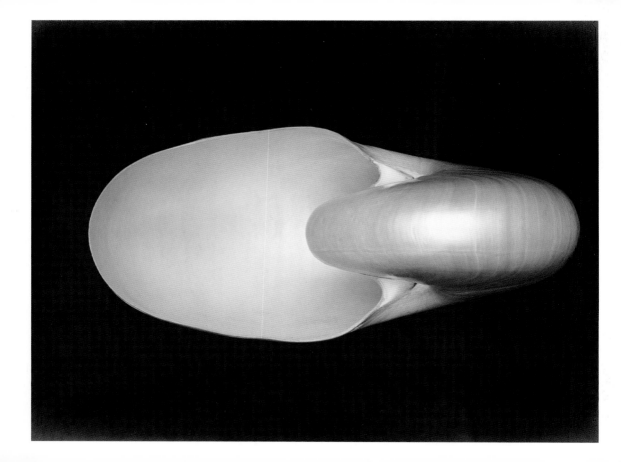

Nautilus 1927
Edward Weston

Against the dark background, the seashell glimmers and appears monumental in shape and size—a modernist fetish. Weston's use of lengthy exposure and a 10 x 8 camera gives the photographs he made of the nautilus a combination of sharp detail and powerful depth, which emphasizes the shape of the shell. The photograph succeeds because Weston was able to marry technical expertise with an intensity of gaze, which transforms this natural object into both a sculptural form and an erotic presence. He likened the chambered nautilus shell to a "magnolia blossom unfolding" and was intent on capturing its beauty and allure. In his journal, he wrote: "I worked with a clearer vision of sheer aesthetic form. I knew that I was recording from within, my feeling for life as I never had before."

Edward Weston's years as a photographer in Mexico (from 1923 to 1926) were a time of intense experimentation. His relationship with Italian photographer Tina Modotti brought him into contact with Mexico's avant-garde, and his work as a studio portraitist in Mexico City enabled him to refine the technical skills that made his later still life photography so remarkable. Although this photograph of a chambered nautilus shell appears simple and effortless, Weston experimented with numerous different ways of photographing it. In an entry in his daybook in 1927, he recounted: "I wore myself out trying every conceivable texture and tone for [back] grounds: glass, tin cardboard, wool, velvet, even my rubber raincoat."

The hour is late, the light is failing . . . there stands my camera focused, trained like a gun, commanding the shells not to move a hair's breath. And death to anyone who jars out of place what I know shall be a very important negative."

Edward Weston

Gelatin silver print
Museum of Modern Art,
New York, USA

False Hellebore (1926)
Imogen Cunningham
San Francisco Museum
of Modern Art, California, USA

Double Jack in the Pulpit (1988)
Robert Mapplethorpe
Robert Mapplethorpe
Foundation

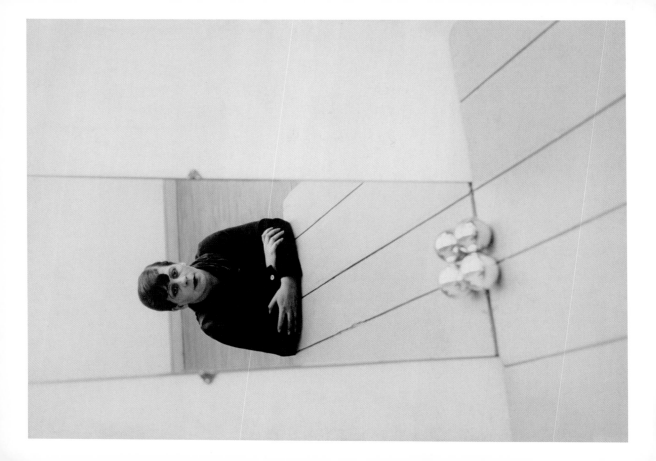

Autoportrait 1929
Florence Henri

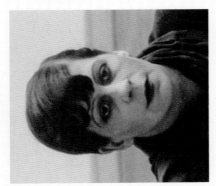

Henri places two polished globes on the floor in front of the sheet of glass, emphasizing that it is a mirror rather than a window, but also playing upon the fact that the mirror is the window to our knowledge of our own physicality. In this way, it becomes a vital part of the intellectual drive of the image. Behind Henri's figure is an expanse of water, giving the illusion that the floor is a jutting boardwalk. The self-portrait speaks of both interior and exterior worlds—the artist as a public person and the private self.

US photographer Florence Henri was a member of the New Vision group in New York and joined the Dessau Bauhaus in 1927. Her Paris studio, which she opened in the late 1920s, produced much innovative work across fashion, editorial, and advertising. Henri's "mirror compositions" show her interest in line, form, and composition; as self-portraits, they provide important information about the interests and creative directions of the photographer. Like many of her contemporaries, Henri was interested in the mask of persona. By using a mirror to photograph herself, she interposes another image—of the self seen through reflection—separated from the "real" by both the lens and the mirror glass.

Gelatin silver print
Galleria Martini & Ronchetti,
Genova, Italy

❝ *It is necessary
that the volumes,
lines, the shadows
and light obey
my will and say
what I want them
to say."*

Florence Henri

✚ *Self-Portrait With Mirror,
East Sussex Coast* (1966)
Bill Brandt Minneapolis
Institute of Arts, Minnesota, USA

*Self-Portrait With Wife June
and Models* (1981)
Helmut Newton

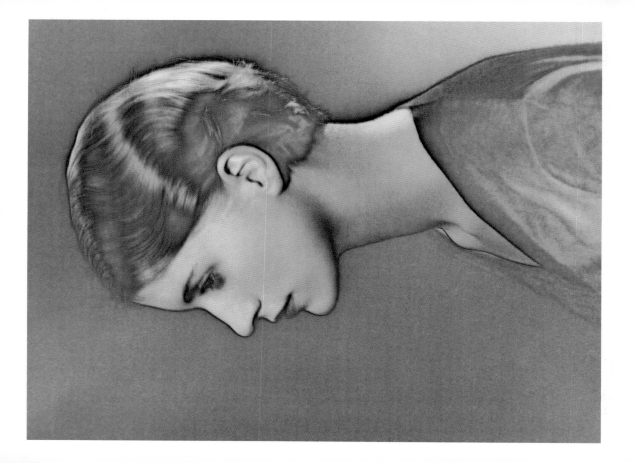

A Solarized Portrait
of Lee Miller 1929 Man Ray

Man Ray concentrated on Miller's profile for this portrait (detail, left), and the solarization emphasized the outline, exaggerating its form and deepening its elegance. Solarization involves a reversal of the image in print form, lightening areas that are dark, and darkening those that are light. The resulting print is silvery, ethereal, and decorative. Lee Miller, who had worked as a fashion model in the United States, was the ideal subject for this portrait, and she emerges from the image as a fantastical being, frail yet entirely modern.

Man Ray's portrait of Lee Miller is the perfect modernist image. Made during the time when Man Ray and Lee Miller were lovers and photographic collaborators in Paris, this solarized image of a young woman—with short hair, an arresting profile, and wearing a simple dress—has remained an enduring symbol of beauty, gracefulness, and style. Both Man Ray and Miller were drawn to surrealism, and their photography invariably reflected this. For Man Ray, photography was "a contemporary development of graphic expression adding to the already large field of painting, drawing, sculpture, etching, lithography, etc. . . ."

 I paint what cannot be photographed, that which comes from the imagination or from dreams, or from an unconscious drive. I photograph the things that I do not wish to paint, the things which already have an existence."

Man Ray

Gelatin silver print
Museum of Modern Art,
New York, USA

Solarization, Orvieto, Italy (1955)
Herbert List

Nu Solarisé (1936)
Francis Bruguière

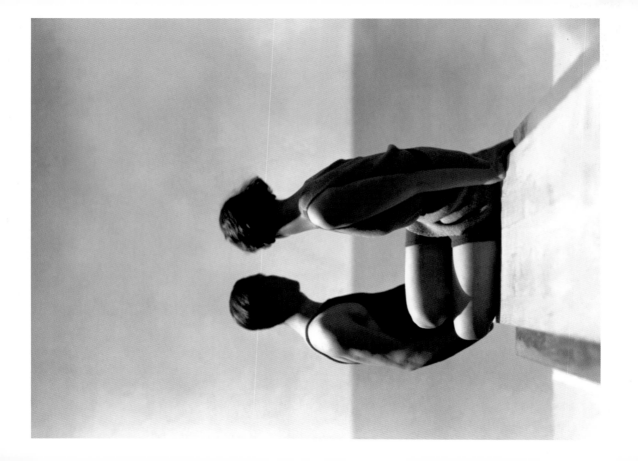

Divers 1930
George Hoyningen-Huene

Hoyningen-Huene's photograph may appear casual, but it is made with exactitude; every element is considered carefully, from the shadows that fall across the two figures, indicating strong sunshine, to the precise alignment of the two heads. The photographer makes a clear distinction between masculinity and femininity in this image, emphasizing the muscularity of the male torso and the delicate slenderness of the female body. The tonal contrasts and bold graphic style are characteristic of Hoyningen-Huene's fashion photography.

George Hoyningen-Huene's photograph of two glamorous models (one of whom was the photographer Horst P. Horst) has become an emblematic image of the Bright Young Things, dwelling in a Gatsby-esque world of beauty and privilege. Hoyningen-Huene was a visionary of prewar fashion photography. He anticipated a new kind of fashion imagery, where bodies were posed informally and forms were fluid. He was also a master of studio technique. Although the models are sitting on boxes, gazing at a backdrop, the photograph creates the perfect vision of heat, health, and elegance, with a restrained sexual frisson.

" ... no matter how much I had planned the overall effect ... I would return to the simplicity and calm of an unencumbered scene and concentrate on the mood and attitude of the model."

George Hoyningen-Huene

Gelatin silver print
Staley-Wise Gallery,
New York, USA

Jogging on the Beach (1934)
Martin Munkácsi
Joan Munkacsi, Woodstock,
New York, USA

Boom for Brown Beavers (1939)
Toni Frissell
Library of Congress,
Washington, D.C., USA

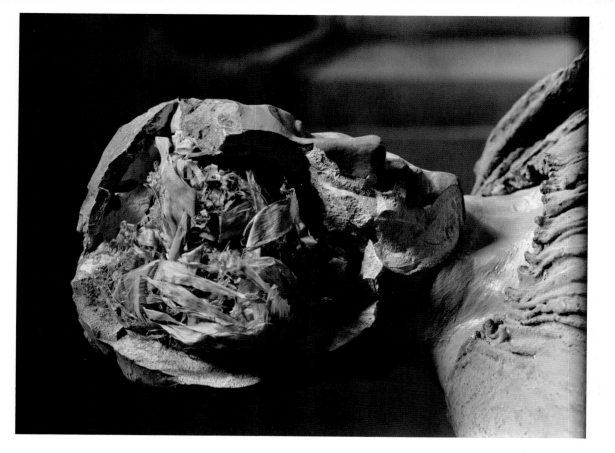

Plaster Head 1945
Josef Sudek

There is abjectness in *Plaster Head* that makes the photograph far more than a simple depiction of a broken work of art. Sudek, who venerated objects and saw sublimity in the simplest of domestic arrangements, was always conscious of a sense of loss, of time passing, and of the quixotic nature of the everyday. Interviewed in 1976, he remarked: "I like to relate the lives of inanimate objects, of something mysterious, like the seventh side of a dice Photography loves mundane objects, and I love the lives of objects."

Josef Sudek was a Czech photographer who lived and worked in Prague. He made many intimate and melancholic still life photographs, as well as elegiac images of domestic and church interiors and shadowy streetscapes. *Plaster Head* was made at the height of his artistic maturity, and the photograph succeeds because it contrasts the beauty of the sculpture with the dissonance created by its fracture and disfigurement. Sudek used a large format camera on a tripod to make his highly detailed and precisely composed photographs. His prints were made from the negative without enlargement.

> **"** *Everything around us, dead or alive, in the eyes of a crazy photographer mysteriously takes on many variations, so that a seemingly dead object comes to life through light or by its surroundings."*
>
> **Josef Sudek**

Gelatin silver print
San Francisco Museum
of Modern Art, California, USA

The Dwarf (1958)
Bruce Davidson

*Blind Home, St. Paul,
Minnesota* (1963)
Jerome Liebling

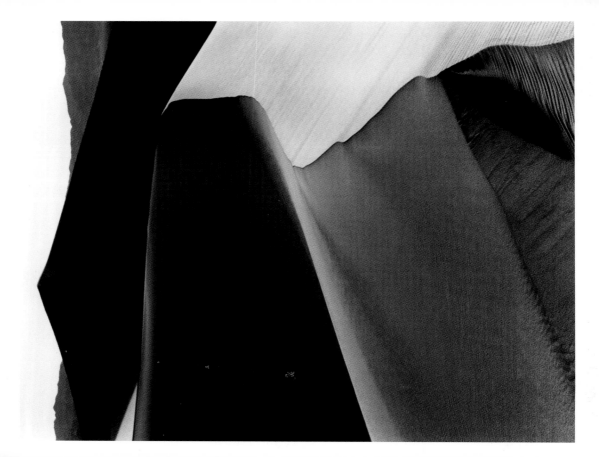

Sand Dunes, Sunrise 1948
Ansel Adams

Sand Dunes, Sunrise is a photograph of place seen as a series of razor-sharp lines, bright expanses, and deep shadows, yet it depicts an identifiable and named location: Death Valley National Park. Adams had to overcome a number of challenges in the making of the image because the shape of the dunes changed with the wind, and he had to find a method to render the shadows tonal in the sharp light of the desert morning. He was acutely aware of the formal qualities of landscape but did not render it as an abstraction.

For Ansel Adams, all stages in the making of a photograph were equally important, and he visualized an image from its framing in the lens until its final production as a print. He had made several attempts at capturing the beauty of the sunrise over Death Valley but had arrived at the dunes too late to photograph the particular light effects that he knew the sunrise could produce. On this occasion, he caught the sunrise at the exact moment he had visualized it. His mantra "Expose for the shadows, develop for the highlights" formed the basis of the Zone System, a technique developed by Adams and Fred Archer, which enabled the photographer to accurately determine the final photographic result.

❝ *In some photographs the essence of light and space dominate; in others, the substance of rock and wood, and the luminous insistence of growing things....*

Ansel Adams

Gelatin silver print
Photographer's collection

Dunes, Oceano (1936)
Edward Weston
Metropolitan Museum of Art, New York, USA

The Minarets from Tarn Above Lake Ediza (1950)
Philip Hyde

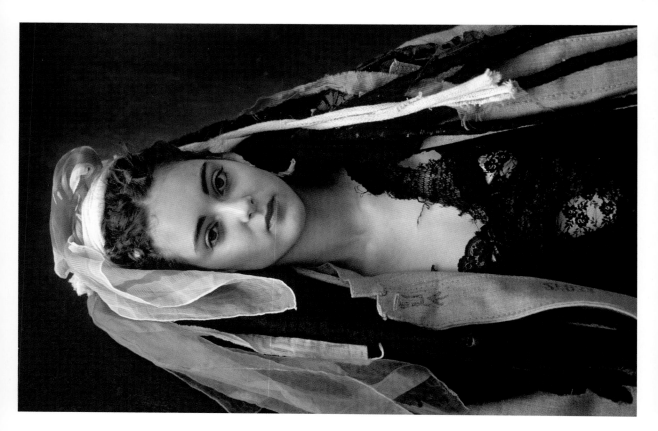

Helena, Sloane Square 1982
Derek Ridgers

Street fashion photography at its very best, this photograph encapsulates an era of style but does not objectify its subject. The strength of the image lies in its choice of subject, and in the way that Ridgers frames the photograph, cropping in tightly and focusing on the face and headdress.

Helena emerges as a real young woman, not a "type," a goddess of street style. Ridgers is careful to portray her costume but also to concentrate on her clear and direct gaze. The result is a striking documentary portrait rather than a fashion photograph.

London-based photographer Derek Ridgers became interested in the new style subcultures that emerged in London during the late 1970s. The beautiful young people Ridgers photographed were highly inventive, fascinated by costume, designing and crafting their individualistic assemblages of clothes and accessories. They were also members of an informal fashion and style tribe, who posed instinctively for Ridgers. This photograph is a collaboration between photographer and subject—each is entirely aware of the other's aims and needs—in which Ridgers bears witness to a remarkable moment in British culture.

Art produces ugly things which frequently become beautiful with time. Fashion, on the other hand, produces beautiful things which always become ugly with time."
Jean Cocteau poet

Jean Shrimpton, New York (1962) **David Bailey**

Tiny in her Halloween Costume (1983) **Mary Ellen Mark** Mary Ellen Mark Library, New York, USA

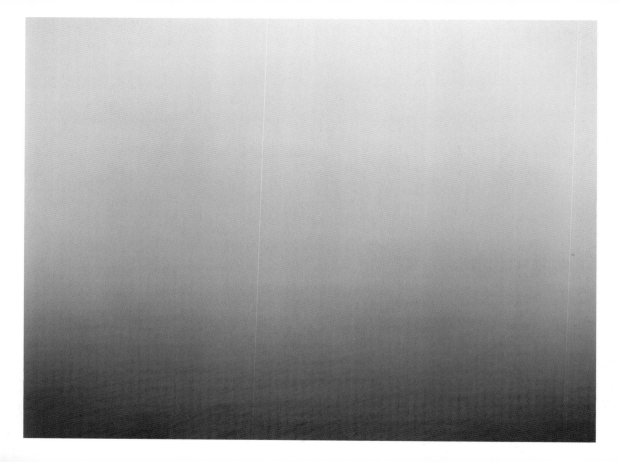

Baltic Sea, Rugen 1996
Hiroshi Sugimoto

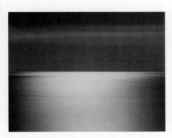

Sugimoto titles each of his seascapes with the name of the place in which it was made—*North Atlantic, Cape Breton* (1996, left), for example—fashioning the series into a project that challenges the idea of national identities and borderlines. He uses the seascapes to map the world; the photographs do not depict cities and mountains, but expanses of water, each with its own identity. Sugimoto describes his relationship with the sea as "a voyage of seeing," and these deep, detailed images become a metaphor for personal adventures. Although the images are made in Germany, Jamaica, Italy, and a host of other countries, the sea defies any attempt to define or categorize it.

Baltic Sea, Rugen is one of the remarkable photographs from the series of seascapes produced by Hiroshi Sugimoto in the 1990s. Writing about his relationship with the sea, Sugimoto comments: "Mystery of mysteries, water and air are right there before us in the sea. Every time I view the sea, I feel a calming sense of security, as if visiting my ancestral home; I embark on a voyage of seeing." *Baltic Sea, Rugen* is a subtle gradation of grays, and the division between sea and sky is minimal. Made with a large format camera, this image captures not only the luminosity of water and sky, but also a deep melancholic threat of darkness and storm.

I let the camera capture whatever it captures . . . whether you believe it or not is up to you; it's not my responsibility."
Hiroshi Sugimoto

Gelatin silver print
Fraenkel Gallery, San Francisco, California, USA

The Brig (1856)
Gustave Le Gray
Victoria & Albert Museum, London, UK

Seascape at Night (c.1872)
Henry Peach Robinson and Nelson King Cherrill National Media Museum, Bradford, UK

Mount McKinley and Wonder Lake, Alaska (1947) **Ansel Adams**
San Francisico Museum of Modern Art, California, USA

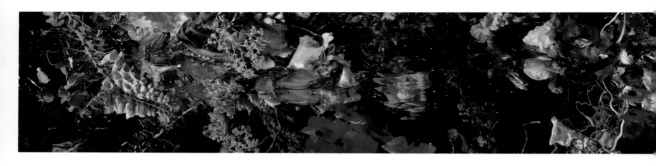

 Margriet Smulders's photographs of flowers are highly ambivalent. Inspired by seventeenth-century painting and informed by Smulders's earlier work around family and domesticity, these images comment on beauty and decay. The flowers Smulders photographs—often using a mirror—float and appear to be on the edge of disintegration. She describes them as "actors" depicting "the whole world, with its relationships and dramas played out by flowers."

> *Lush and strangely erotic tableaux entice you into another dimension. Huge mirrors, elaborate glass vases, rich draperies, fruit, and cut blooms are used to make these 'paintings.'*
> **Margriet Smulders**

 Cibachrome print
49 x 433 in (125 x 1100 cm)
Private collection

Monsoon Flora, India (1983)
Steve McCurry

Tulip series (2001)
Dennis Stock

Arch series (2007–08)
Susan Derges

Amor Omnia Vincit 2005
Margriet Smulders

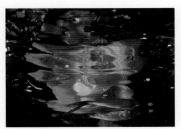

There is a subtle menace in Smulders's photograph: twisted twigs cut across the composition, and the blue watery center of the image is a void, which threatens to engulf the floral fragility. Although Smulders has used the classic photographic genre of still life, color is exaggerated and hyperreal, combining to create a jarring effect that is far removed from the perceived idea of the flower photograph. Like many contemporary photographers, including Helen Chadwick and Susan Derges, Smulders has perceived death in nature, the inevitability of decay. Flowers emerge from the image like teeth and tongues; body parts drift in liquid, destined to rot.

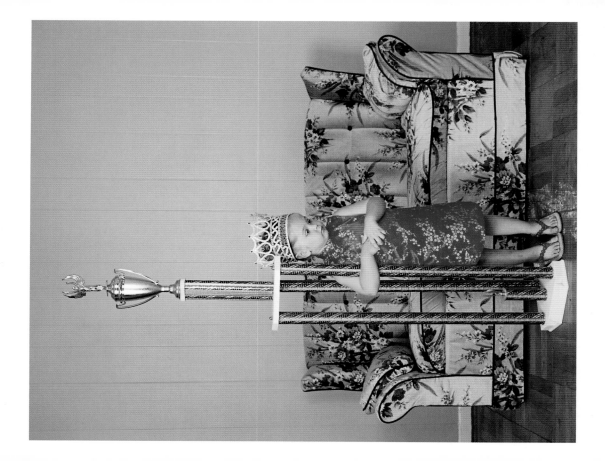

BEAUTY
STILL MOMENT

Rayne-Lin, Little Miss Firecracker, L.A. 2006 Colby Katz

Katz has seized upon a still moment in a busy day, and her photograph poses gentle but probing questions about a society that dresses up its young and exposes them to the fierceness of competition and the ever-present specter of disappointment. By positioning the child in front of a sofa, Katz suggests domesticity, but this is the faux homeliness of a hotel room, transitory and unfamiliar. Katz's combination of documentary opportunism and knowledge of the subject, as well as a particular empathy, makes this image so successful.

Colby Katz's photographs of the US pageant scene avoid the sensational—to satirize this phenomenon would be simple. Instead, Katz explores behind the scenes, documenting but not judging. This photograph of a young girl posing beside a trophy is skillfully seen. The surroundings are bland, far away from the world of chaos and play that is usually attached to studies of infancy. It is a study in weariness, as the child leans against the garish trophy plinth, eyes downcast, a baby's face in an adult world of ambition and show. Katz comments on the absurdity of the pageant, yet expresses an understanding for those who, through their children, aspire to the fame and celebrity so prized in Western society.

 I have an odd family. My grandma was a midget. There are strippers, a brothel owner . . . our upbringing makes us who we are."

Colby Katz

Chromogenic print
Photographer's collection

"Girls in Beauty Contest" from the series Butlins by the Sea (1972)
Martin Parr

"Patsy" from the series Blind Prom (2008)
Sarah Wilson

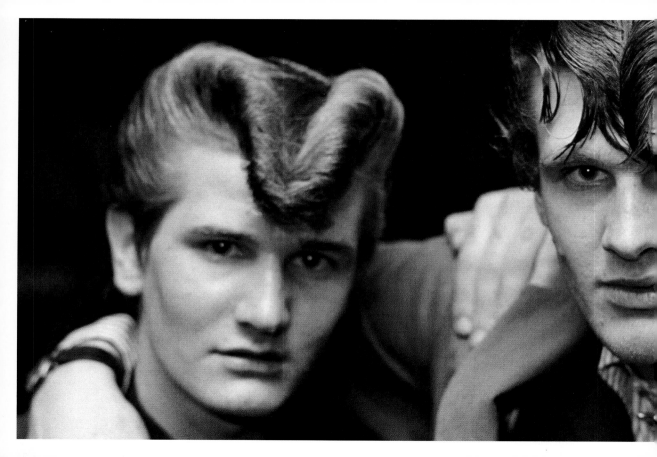

RELATIONSHIPS

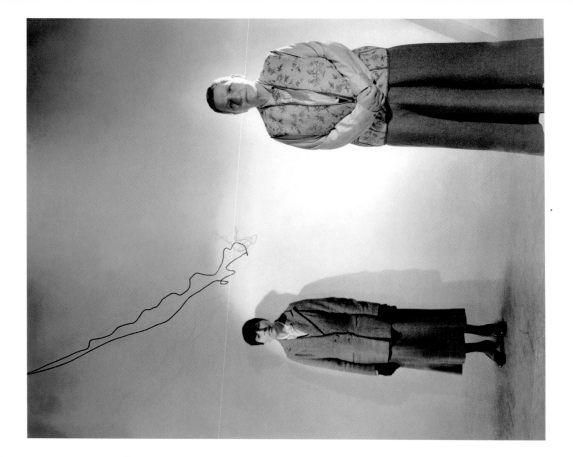

Gertrude Stein and Alice
B. Toklas 1936 Cecil Beaton

Beaton includes a twisted strand of electrical wire that adds tension to the image, reinforced by the juxtaposition of the two subjects. The photographer found Stein and Toklas to be "quite a startling-looking couple" yet immensely dignified. He made no attempt to glamorize them, and by photographing them together, but separated by stark white space, he intensifies both their unity and their individuality. The light that illuminates the space between them gives a central focus to the image.

In whatever juxtaposition I took them, the effect was incongruous and strange; yet so great was the integrity of their characters that they could not possibly be made to look ridiculous."

Cecil Beaton

Uninterested in technique, Cecil Beaton relied, in all his portraits, on the collaboration of his subjects, and his own ability to define and portray character and relationship through photography. In this image of Gertrude Stein and Alice B. Toklas, there is no attempt to glamorize the women nor their relationship—Stein's hands are crossed in front of her patterned jacket; Toklas stands apart in a plain suit toward the back of the photograph. Beaton made a number of photographs in this series. He clearly thought that this image was the most successful, selecting it for a number of major retrospectives in the 1970s.

Gelatin silver print
Cecil Beaton Studio Archive

Goya Fashion (1940)
Horst P. Horst
Horst Estate, Miami,
Florida, USA

Simiane-la-Rotunde (1969)
Henri Cartier-Bresson
Museum of Modern Art,
Paris, France

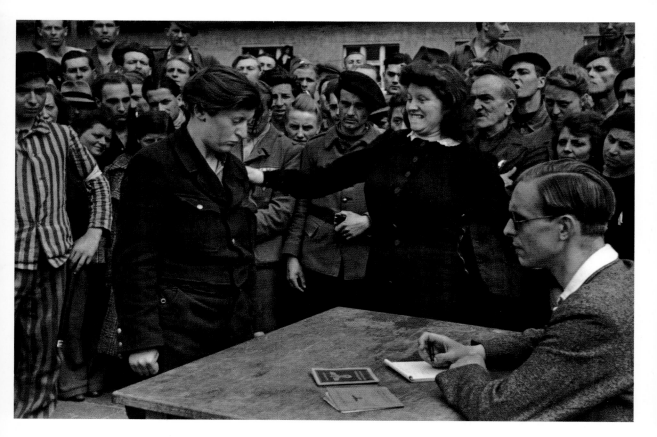

Gestapo Informer, Dessau, Germany 1945
Henri Cartier-Bresson

The dramatic focus of *Gestapo Informer* is the relationship between the three central people—the collaborator, an official, and a furious accuser. The official is dispassionate, the accused bows her head, and the accuser grimaces. This dynamic triangle of characters gives the image structure and focus. The background is formed of three more triangles, made up of faces from the crowd. Within this crowd of onlookers is a man wearing the striped uniform of a concentration camp prisoner. This figure draws viewers' attention to the far left edge of the frame and provides contextual information.

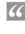

Photographing with a 35mm Leica camera, Henri Cartier-Bresson was producing both a news photograph and a dramatic image of the aftermath of World War II. The French photojournalist became a member of the French Army's Film and Photo Unit when the war began in 1939. After time spent as a prisoner of war, he then worked for the French Resistance. Capturing what he would call "the decisive moment"—here the denouncing of a suspected Gestapo informer—he illustrates his acute visual awareness and sense of documentary immediacy. The image is a sharp-edged, angular composition, awash with expressions of rage, shame, anguish, and resignation.

I craved to seize the whole essence ... of some situation that was in the process of unrolling itself before my eyes."

Henri Cartier-Bresson

Gelatin silver print
National Media Museum,
Bradford, UK

"Army Wallpaper" from
the series *I Can Help* (1988)
Paul Reas

*Dresie and Casie, Twins,
Western Transvaal* (1993)
Roger Ballen

"Caroline and Anthony"
from the series *21st Century
Types* (2005)
Grace Lau

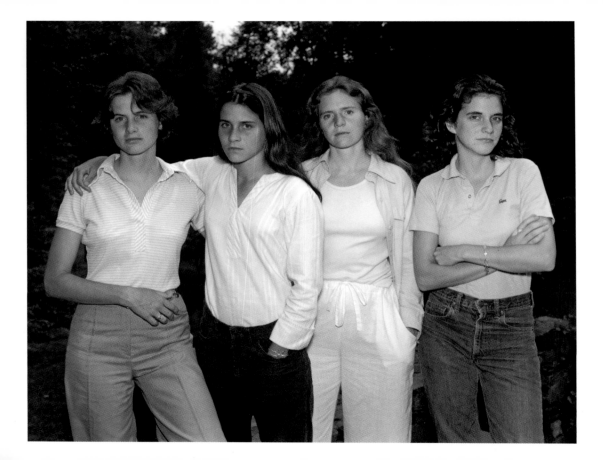

The Brown Sisters, New Canaan 1975
Nicholas Nixon

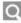

The ritual of making a photograph every year has become part of the Brown family tradition, and it is always taken at a family gathering (2010, left); for Nixon, it is "a way to mark time." The sisters always stand in the same order and look at the camera. *The Brown Sisters* series owes much to the family snapshot, and the composition echoes family photographs that have been taken since the beginnings of photography. However, Nixon vastly extends the parameters of the snapshot by his complicity with his subjects, and by his meticulous attention to expression, gesture, and form. Consequently, the photographs are powerful both as a series and as single images.

In 1975, Nicholas Nixon made the first photograph in the series *The Brown Sisters*. It is about youth—fluid bodies, young women exploring their relationships with each other within the formal frame of the photograph. Relationships are subtly drawn. Heather and Mimi stand with arms around each other, whereas Bebe, the photographer's wife, stands slightly to the back of the group, both distant from and complicit with the photographer. Laurie has her arms folded, unsure perhaps of the significance of the process.

The photographs of the Brown sisters were completely casual. We all liked one photograph a lot, and there raised the drive, which created the idea. The same idea, which occurs to most parents."

Nicholas Nixon

Gelatin silver print
Fraenkel Gallery,
San Francisco, California, USA

Migrant Family from Missouri Camping Out in Cane Brush (1939)
Marion Post Wolcott
Smithsonian American Art Museum

Alison (1978)
Jack Radcliffe

The Damm Family in Their Car, Los Angeles (1987)
Mary Ellen Mark

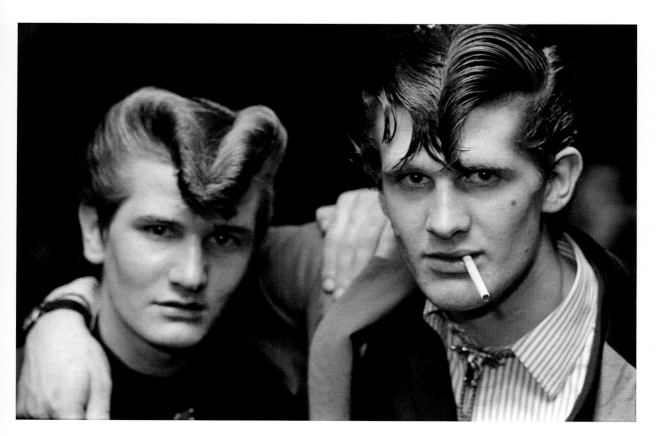

From the series *The Teds* 1976
Chris Steele-Perkins

This is a complex photograph about friendship, style, and masculinity. Like many successful documentary images, it acts as witness to cultures that otherwise would become insubstantial with the passing of time. The hand at the center of the image is vital to the composition. Elegant and somewhat feminine, it expresses both vulnerability and tentativeness, as the two men define their sexuality before the camera. Both subjects meet the photographer's gaze, but the young man on the right is more assertive than his companion, who is a calmer, unruffled presence.

Chris Steele-Perkins's photograph of two teddy boys in the mid-1970s is a direct, close-up portrait of two young men, almost identically quiffed. The two men are clearly posing for a portrait, aware of their stylishness and membership of a subculture. Steele-Perkins uses their enthusiasm to be photographed to come in very close to his subjects, capturing every detail of their faces against a black background. He photographs an intimate moment of youth and bravado: the two men—confident in their masculinity—have their arms around each other, but there is no sense of an erotic engagement. United by style, they are formidable.

I like to think that in fifty years' time when people look back to teenage culture in the late twentieth century, The Teds *will [be] part of the repertoire."*
Chris Steele-Perkins

Gelatin silver print
Photographer's collection

Skinheads, Brighton (1980)
Derek Ridgers

Punk Rock Celebration, Tokyo, Japan (1984)
Burt Glinn

Hawleywood's (2005)
Jennifer Greenburg
Museum of Contemporary Photography, Illinois, USA

79

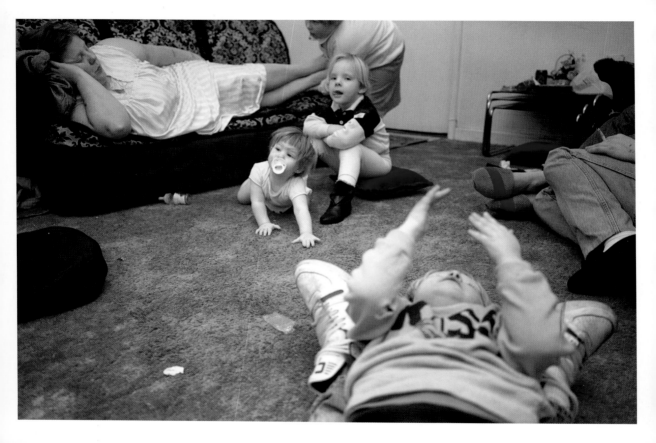

From the series *Living Room* 1982–97
Nick Waplington

This photograph succeeds because of Waplington's acute spatial awareness. He captures a moment when the child in the foreground raises her hands, the infant in the center extends her arms to crawl, and the child in the background is still. To the right are the denim-clad legs of two figures who are only partially seen, framing the composition so that attention is focused on the children before absorbing the whole family tableau. The photograph may appear casual, but it is highly disciplined, carefully observed, and meticulously structured. It is taken at child level, using the patterned carpet as a background and excluding any other details of the room.

Nick Waplington's extended series of photographs of family life was made on a Nottingham council estate. He had close family connections on the estate, which gave him the access needed to produce this intimate and powerful study of domestic life. The work represents a school of documentary photography that involves the long-term portraiture of a specific group of people. This photograph of a family relaxing in their living room, though ostensibly a study of a closely related group, is in fact a focused exploration of individuals, each absorbed in their own activity.

The antics of his uninhibited subjects are barely contained within the frame, lending these unpretentious glances at domestic life a fresh, irreverent verve."

Camera and Darkroom magazine

Chromogenic print
Photographer's collection

Ring Toss (1899)
Clarence White
Library of Congress,
Washington, D.C., USA

Southam Street series
(1956–61)
Roger Mayne

The Dyer Family (1985)
Peter Marlow

My wife is ACCEPTABLE.
Our relationship is satisfactory.

Edgar D.

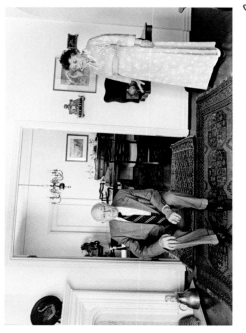

Edgar looks splendid here. His power and strength of character come through. He is a very private person who is not demonstrative of his affection; that has never made me unhappy. I accept him as he is. We are totally devoted to each other.

Regina Goldstine

Dear Jim:
May you be as lucky in marriage!

From the series *Rich and Poor*
1985 Jim Goldberg

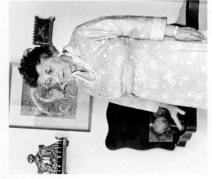

Without the text, this would have been a simple portrait study, but the handwritten text brings the photograph alive. Regina writes effusively of her husband's "strength of character" and, more tellingly, of his inability to be affectionate or open. "Edgar," she writes, "has never made me unhappy. I accept him as he is." Edgar's comments are terse: "My wife is acceptable. Our relationship is satisfactory." Are Edgar's comments about Regina brutal, or are they a rejection of a confessional culture, which demands that we tell all?

This image is from a series of portraits of people from opposite ends of the social strata, who were invited to write about themselves and their portrait. The results, written directly onto the photographic print, were revealing, moving, and intensely personal. Jim Goldberg worked closely with his subjects to ensure that the texts were powerful and expressive. This photograph of Regina and Edgar, an elderly married couple posing in their living room, is perhaps the best known of the series. It works because it is extraordinarily open: combining image and text, it presents a dialogue between the subject and the photographer and does not allow the viewer to reach simple conclusions about complex relationships.

> *I have the great privilege of being both witness and storyteller. Intimacy, trust, and intuition guide my work.*
>
> Jim Goldberg

Photographer's collection

Pictures from Home series (1982–91)
Larry Sultan

Good Memory, The Classmates (1996) Marcelo Brodsky
Museo Nacional de Bellas Artes, Buenos Aires, Argentina

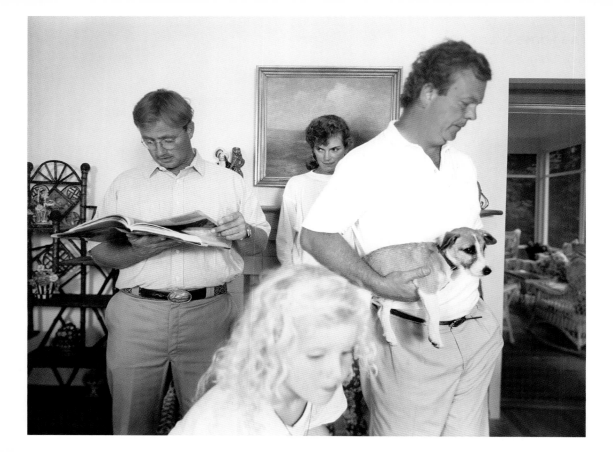

The Landscape 1988
Tina Barney

The large scale of Barney's photograph makes everyday life seem monumental, and her highly detailed photograph enables the viewer to become part of the documentary fiction that she creates. In *The Landscape,* she constructs a composition within which the two women are the passive centers of the photograph. The male figures are more fully portrayed; in contrast to the two women, they are active and concentrated—one is absorbed in a newspaper; another strides purposefully, holding a dog. Barney establishes a tension among the group, and there is dissonance and distraction within the relationships.

Tina Barney photographs friends and family in their domestic environments. In this image the people are separate yet intensely involved with each other. All seem preoccupied with their activities, joined only by relationship. The image is a stage setting for a carefully choreographed reality, with domestic objects and furnishings providing a backdrop for the enigmatic scenario. *The Landscape* succeeds because it is carefully controlled; tension is hinted at but meticulously limited by the banality of the scene.

The longer you work together, the better you know each other, and the better the working situation develops. A lot of my subjects now feel as if they're collaborating with me, which is more fun than ever."

Tina Barney

Chromogenic print
Museum of Modern Art,
New York, USA

Elevator—Miami Beach (1955)
Robert Frank
Philadelphia Museum of Art, USA

"Sorry Game" from the series
Immediate Family (1989)
Sally Mann

Sign of the Times project (1992)
Martin Parr

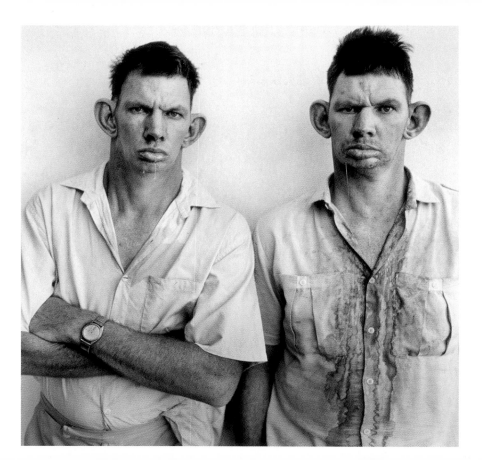

Dresie and Casie, Twins, Western Transvaal 1993
Roger Ballen

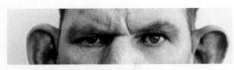
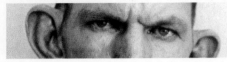

Dresie and Casie succeeds on a number of levels. The two men appear to collaborate with the photographer rather than being his unknowing subjects. Their gaze is stern and watchful, and there is no doubt that they are aware of the process of which they are a part. As twins, they emerge as distorted mirrors of each other, worked on by nature, yet maintaining a distinct similarity. These men are clearly members of an impoverished community, and this photograph imbues their characters with a particular dignity.

Dresie and Casie was first published in Roger Ballen's monograph *Platteland,* and he noted: "The concept was trying to photograph or document an archetypal group of people living in the South African countryside, faced with revolution, fear, alienation, isolation, and rejection." This image is about family, relationship, and a specific closeness; it is more testament than document. It is also about physicality, and the figures of the two men fill the frame in a way that leaves no space for extraneous detail. Ballen gives no other information about his subjects; viewers do not know how or where they live. Embedded in their own space, they have resilience and awareness.

[My] goal as an artist is to create increasingly complex images with greater and greater clarity of form and intensity of vision."
Roger Ballen

Selenium toned gelatin silver print
The Cartin Collection, Wadsworth
Atheneum Museum of Art,
Connecticut, USA

*Two Women, Lansdale,
Arkansas* (1936)
Margaret Bourke-White
Syracuse University, New York, USA

*Unititled, East 100th
Street* (1966)
Bruce Davidson

*Identical Twins, Roselle,
New Jersey* (1967)
Diane Arbus

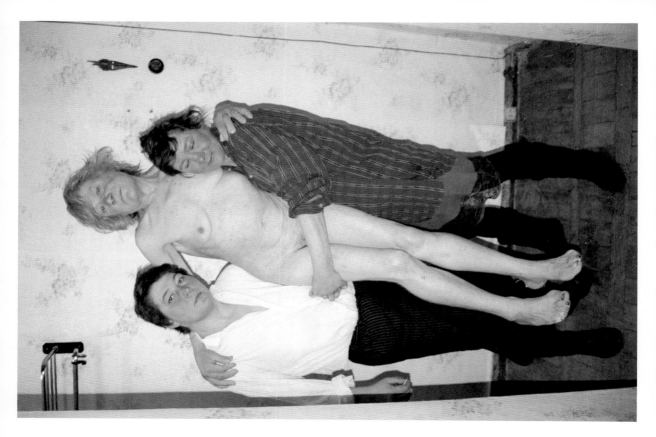

From the series *Case History*

1997–98 Boris Mikhailov

Mikhailov photographs his subjects in an interior setting, but there is no feeling of "home." The naked woman stares at the camera and clasps the shoulders of her two caregivers as they lift her from the floor. There is resignation and a certain beauty in this coldly lit photograph. The power of Mikhailov's photographs comes partly from his subjects, from his access to them and their obvious trust in him, but also from the careful positioning of all three figures, seemingly casual, but clearly and meticulously placed within the frame.

Boris Mikhailov's series *Case History* was made in the Ukraine in the aftermath of the breakup of the former Soviet Union. Consisting of 400 photographs, the work was made in and around the city of Kharkov. *Case History* documents the lives of people living on the margins of society, a large number of whom were made homeless by the collapse of communism. They appear as grotesques, and it is Mikhailov's unflinching eye that presents viewers with this spectacle of a failing society. In this image, Mikhailov depicts the relationship between two female caregivers and the frail, naked figure whom they hold. The contrast between their neat clothes and the stiff, aging body of their companion is a stark one.

They say about me, that I proceed like a cat hiding, watching. I am waiting for the best moment to push the button of the camera.

Boris Mikhailov

Chromogenic print
Photographer's collection

People Living in Miserable Poverty, Elm Grove, Oklahoma County, Oklahoma (1936)
Dorothea Lange

Gypsies series (1960s)
Josef Koudelka

Self-Portrait as My Father Brian Wearing 2003 Gillian Wearing

Wearing's self-portraits explore photography as masquerade and also examine ideas of identity and representation. With meticulous attention to detail and using sophisticated silicon prosthetics, Wearing creates extraordinary self-portraits of herself as her family members based on snapshots from the family's photograph album. Her images are successful because they pose questions about family, relationships, and the self, which all remain important within contemporary photography. Others in the series include her brother, grandmother, and grandfather.

Turner Prize winner Gillian Wearing made this portrait of herself as her father as one of a group of photographs in which she poses as members of her family. The series began in 2003 with her *Self-Portrait as My Mother Jean Gregory* (above). In the photographs, Wearing addresses the issues of family resemblances and relationships. She "imagines" her father through costume, hair, and makeup, and also through the careful styling of a postwar studio portrait. Although Wearing's photographic work has been positioned within fine art, it owes much to the tradition of studio photography, and to photographic history. In this series, her images examine the past and explore the narratives of family relations.

If you ever make anything too literal you might as well forget it. It loses everything. It loses the mystery, which is probably the most alluring factor. . . ."

Gillian Wearing

Chromogenic print
Photographer's collection

Self-Portrait After Marilyn Monroe (1996) **Yasumasa Morimura** The Contemporary Museum, Honolulu

Tracey Emin as Frida Kahlo (2000) **Mary McCartney** Michael Hoppen Gallery, London, UK

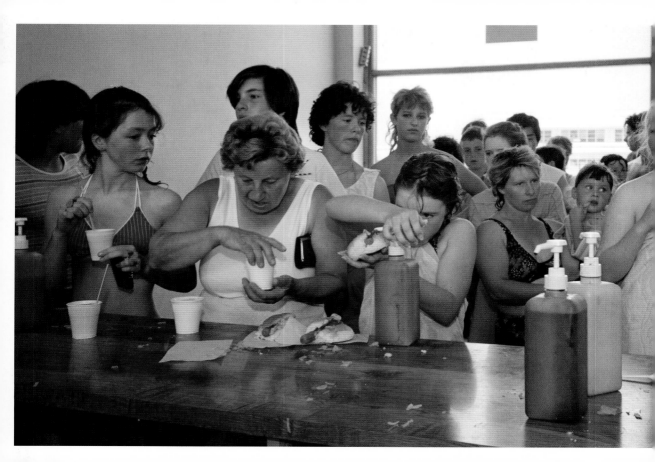

THE EVERYDAY

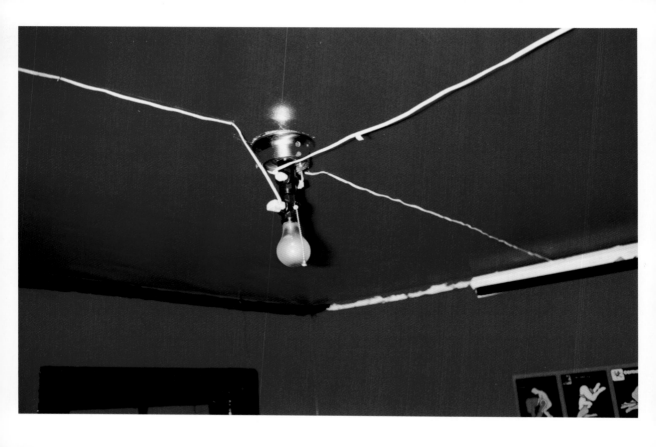

Greenwood, Mississippi 1973
William Eggleston

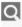

This photograph is startling in its emptiness: it has virtually no content—three wires stretch, weblike, out from the lamp across the ceiling—and extraordinary depth of color. The primary colors in the fraction of artwork draw the eye to the bottom right-hand corner. Eggleston's photographs of everyday life, shot in color, were apparently effortless snapshots taken in and around his neighborhood. According to the photographer, this image was taken when he was lying talking on a bed with two friends: "I looked up and took the picture. And then we continued talking."

William Eggleston's "everyday" world is transformed, through his photographic vision, into a set of intriguing scenarios. *Greenwood, Mississippi* is about making the unremarkable spectacular, and there is so much not present in the image that viewers inevitably begin to construct their own narrative. Much of Eggleston's work from the 1970s is proof of photography's ability to transform real life into narrative fiction. The images are printed using the dye-transfer process, ensuring a depth of color and tone that has come to typify Eggleston's photographic prints.

I only ever take one picture of one thing. Literally. Never two. So then that picture is taken and then the next one is waiting somewhere else . . . I don't really worry if it works out or not."

William Eggleston

Dye-transfer print
J. Paul Getty Museum,
Los Angeles, California, USA

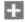

At the Petrol Refinery (1982)
Abbas

*Pandora's Box,
Client Lounge* (1995)
Susan Meiselas

In Praise of Shadows
series (2008)
Eugen Sakhnenko

From the series *Beyond Caring* 1984–85
Paul Graham

Graham was interested in noncolor, and *Beyond Caring* has an extremely restrained color palette, which reflects the society that the photographer was documenting. He made the Department of Health and Social Security images secretly, and here he creates a scene of profound boredom and despair. The photograph appears to have a "haphazard composition," achieved using "tilted verticals, intrusions, and excesses of floor and ceiling." Graham was particularly drawn to the lack of color in the waiting rooms, commenting that they had been "leached of all color, drained of hope, and left only with a fluorescent flicker, nicotine-stained ceilings, and puce lemon-green walls."

Paul Graham made *Beyond Caring* for a commission from the Photographers Gallery, who asked him to photograph whatever he felt was important in Britain in 1984. The series introduced a new visual vocabulary into British documentary photography. At a time when the British welfare system was being eroded by the radical social policies of the Thatcher government, Graham's photographs of the everyday bleak interiors of unemployment benefit offices epitomized the image of the United Kingdom as a nation in decline.

The photography I most respect pulls something out of the ether of nothingness . . . you can't sum up the results in a single line. In a way, 'a shimmer of possibility' is really about these nothing moments in life."
Paul Graham

Color coupler print
Photographer's collection

New York (1945)
Helen Levitt
Judith Mamiye Collection, New Jersey, USA

Yates's Wine Lodges (1983)
Martin Parr

Displaced Persons Camp, Rwanda, Africa (2003)
Ian Berry

97

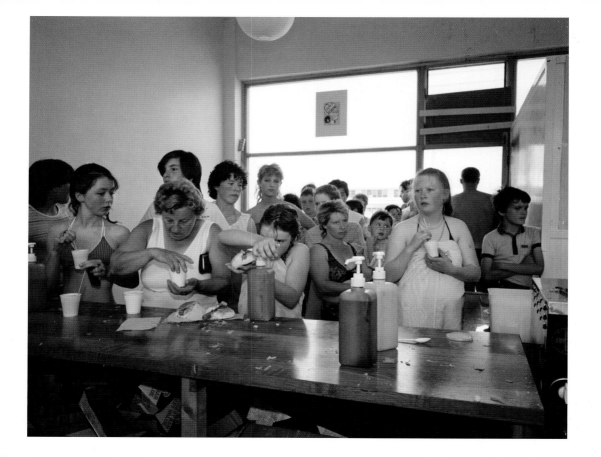

From the series *The Last Resort* 1986
Martin Parr

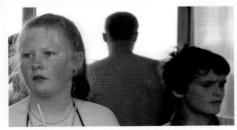

A crowd of women waits in a disorganized queue for hot dogs and drinks. Parr stands behind the counter to take the picture, giving the viewer a privileged insider's view. As he foregrounds the service counter, with its food scraps, plastic containers of sauces, and smeared surfaces, he creates a barrier between photographer and subject. In the doorway, a solitary man stands with his back to the queue, distanced from this female battle for sustenance. Parr captures gesture with consummate skill, and his subjects are like dancers, arrested in mid-routine.

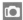

Martin Parr is a documentary photographer who began to make color photography in the 1980s in the United Kingdom. Known in the 1970s for his use of black and white photography to portray the everyday—"ordinary" British people at work and at play—Parr began to photograph the postindustrial society of the Thatcher years in the early 1980s. He was particularly attracted to the decayed British seaside resort of New Brighton, both for its melancholia and its raucousness; he saw it as a metaphor for a nation in decline. In this photograph, an everyday scene becomes a tableau, the women protagonists in a ritual as they gesture and jostle.

I like to create fiction out of reality. I try and do this by taking society's natural prejudice and giving this a twist."

Martin Parr

Chromogenic print
Victoria & Albert Museum,
London, UK

Untitled (Neon Confederate Flag)
(1971–73)
William Eggleston
Edward Cella, Los Angeles, USA

Cove Café (1982)
Jem Southam
Victoria & Albert Museum,
London, UK

Selma, Alabama (2007)
Richard Benson
Museum of Modern Art,
New York, USA

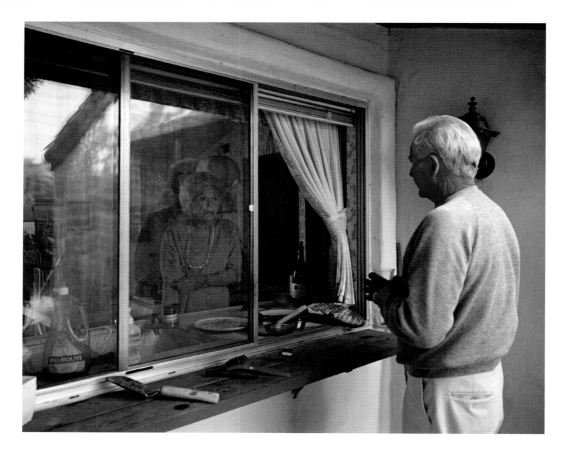

Conversation Through a Kitchen Window 1986
Larry Sultan

Conversation Through a Kitchen Window shows Sultan's parents communicating across the partition of a wall. His father is occupied with home repairs; his mother is alone in the house. Sultan's photograph is about a divide; the window may be open, but there is a defensiveness in pose and attitude of the two subjects, which Sultan recognizes and captures in the image. This photograph presented many technical difficulties: for example, the necessity of representing both figures, one in daylight and one standing in the shade of the house. Sultan photographs his mother as an insubstantial figure, shrouded in shadow, but her presence is central to the narrative.

Larry Sultan's autobiographical work about his parents was first published in the monograph *Pictures from Home*. The series began when his father, Irving, was prematurely retired from corporate life, and it is an intense reflection on the lives of an elderly married couple and the photographer's relationship with them. Photographed on a large format camera, the project was necessarily a collaboration between family members, each enacting a role based on real life.

I wanted to subvert the sentimental home movies and snapshots with my more contentious images of suburban daily life, but at the same time I wished to subvert my images with my parents' insights into my point of view."

Larry Sultan

Chromogenic print
Museum of Contemporary
Photography, Chicago,
Illinois, USA

Ella Watson and Her Adopted Daughter (1942)
Gordon Parks

Living Room series (1987–94)
Nick Waplington

Ray's a Laugh series (1993)
Richard Billingham

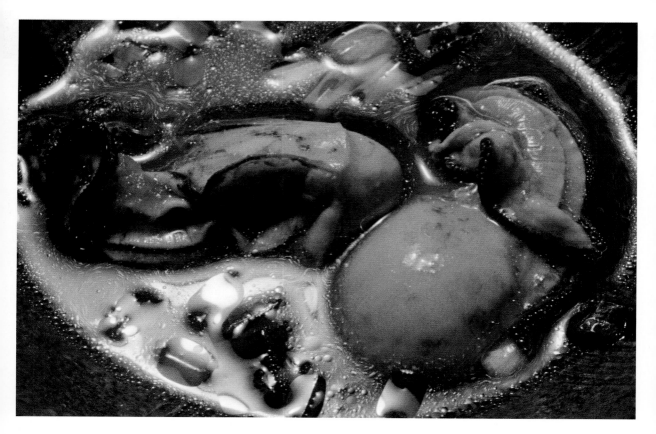

From the series *The Banquet* 1993
Nobuyoshi Araki

THE EVERYDAY
FLESH

In this photograph of a simple plate of food, Araki enters the transgressive territory of mysterious flesh. The food becomes a landscape or an entanglement of limbs, with its own eroticism. Bodily fluids are suggested; there is also a suggestion of entrails, of body parts raw and exposed. Seen in black and white, viewers can only imagine the colors of flesh and skin, and the form of the food becomes a dominant part of the photograph. Araki carefully excludes any background, except for a glimpse of the plate where the food has been laid, which itself glistens with the slimy glaze of the fish.

Nobuyoshi Araki is one of the world's most prolific photographers. Based in Tokyo, he has published numerous books, most of which explore erotica. *The Banquet* is very different: it is an homage to his late wife, Yoko, and takes the form of a photo diary of the food that Araki ate with Yoko in the last months of her life. Divided into black and white and color sections, these photographs explore the color and texture of prepared meals; they are luxuriant photographs of everyday food, which both repel and attract viewers. This image accentuates the fishy fleshiness of the food; it is glaucous, slithery, and almost touchable in its visceral presence.

I would say my sex drive is weaker than most. However, my lens has a permanent erection."

Nobuyoshi Araki

Gelatin silver print
Photographer's collection

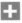

Chocolate Cream Pie (1964)
Robert Watts Jane Voorhees
Zimmerli Art Museum, Rutgers,
State University of New Jersey, USA

Untitled (Donuts) (1995)
Martin Parr
San Francisco Museum
of Modern Art, California, USA

Cabbages, Kimchi Factory, South Korea (2007)
Alex Majoli

From the series *Drum* 1996
Krass Clement

In this photograph, and others in the series (left), figures stumble and loom; they are together but do not seem to communicate. Clement has photographed the men from behind so that they become forms in the photographs, depersonalized and abject. The light in the photograph appears to come from behind the figures, making them into near-silhouettes and throwing the bleak, undecorated walls of the bar into sharp relief. Clement's photograph works so well because it is disciplined and uncompromising. The bar's customers seem to move like automatons in this inhospitable place, occupying a kind of rural Hades.

First published as a monograph, Krass Clement's documentary images of everyday scenes in a rural Irish bar have a darkness and melancholy that distinguish them from other work of the period. This image was used on the cover of *Drum: A Place in Ireland* (1996), and it has become the most emblematic of the series. Desperation and isolation are the predominant motifs of this photograph, as Clement projects his own photographic and emotional sensibilities onto a simple place. It could be said that Danish-born Clement has brought a Nordic sensibility to a country more usually depicted as a deserted Celtic paradise.

[Clement's] photographs raise existential questions about the human condition; they deal with the feelings we have difficulty facing: loss, anxiety, and solitude."
La Lettre de la Photographie

Gelatin silver print
Photographer's collection

In the Public Bar, at Charlie Brown's, Limehouse (c.1942)
Bill Brandt Museum of Modern Art, New York, USA

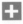
Café Lehmitz series (1978)
Anders Petersen

Williamsburg, Brooklyn (2005)
William Meyers

HOME

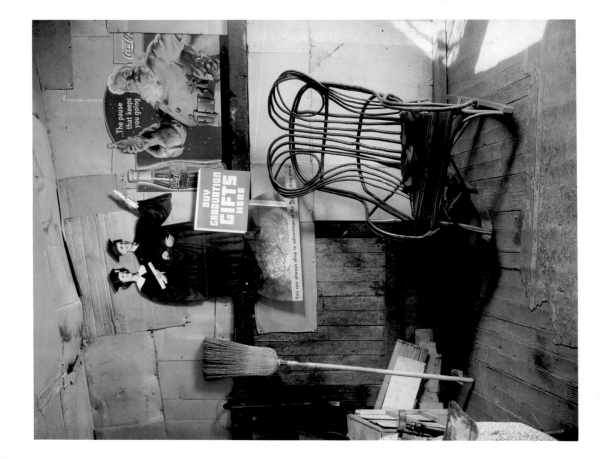

Interior of Coal Miner's Home, West Virginia 1935 Walker Evans

Evans's photograph of this interior is deceptively simple. In it, he exposes a wealth of detail, from the cardboard sheets tacked to the wall to insulate this basic house, to the advertising posters that are used as decoration. The irony of the posters was not lost on Evans: gowned students greet the future with raised hands. The elegance of a wooden rocking chair stands in contrast to the bare boards and rudimentary construction of the house. Although there are no people in the photograph, Evans is acutely aware of their presence; this simple interior is a home, clean and cared for.

Walker Evans made this photograph of the interior of a coal miner's home when he traveled to Morgantown, West Virginia, to photograph the impact of rural poverty for the US government's Farm Security Administration program. The photograph is about symmetry disrupted by the personal—an interior rendered sublime by the accuracy of the photographer's eye— and it has become one of documentary photography's great classics. Evans's observational style of interior photography set a standard, and its influence can be seen throughout postwar photography of the domestic interior.

. . . the matter of art in photography may come down to this: it is the capture and projection of the delights of seeing; it is the defining of observation full and felt."

Walker Evans

Gelatin silver print
Metropolitan Museum of Art,
New York, USA

Television Studio, Burbank, California (1955)
Robert Frank
Art Institute of Chicago, USA

Philadelphia, Pennsylvania (1961) **Lee Friedlander**
Museum of Modern Art,
New York, USA

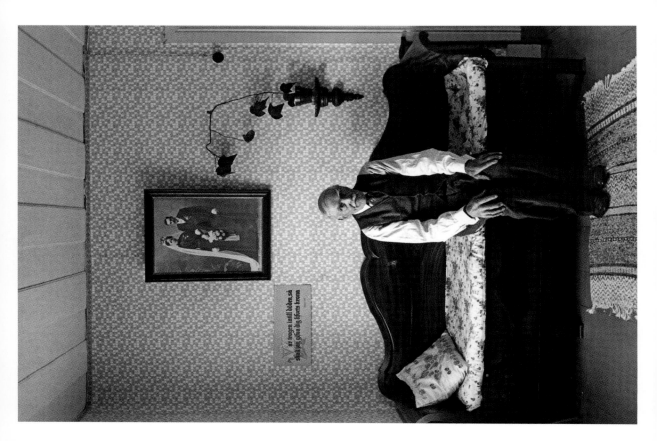

From the series *Västerbotten*
1950s–60s Sune Jonsson

In this photograph, an elderly man sits stiffly for his portrait; he wears his Sunday clothes, wanting to look his best on this important occasion. Behind him is a framed photograph of a wedding, possibly his own; a religious tract; and a plant in a wooden holder. The age and type of the interior is carefully revealed by Jonsson in a sliver of wooden ceiling, glimpsed at the top of the photograph. Jonsson's studies of these dignified, isolated people are some of the best examples of Nordic postwar documentary; little known outside the Nordic countries, they are documentary portraiture at its incisive best.

Swedish documentary photographer Sune Jonsson studied the lives of rural people in the northern Swedish district of Västerbotten during the 1950s and 1960s, while he was employed by the local museum. His photographs are distinguished by their simplicity and their ability to create a narrative through the portraiture of people in domestic and working environments. Jonsson photographed these hardy rural people with a sympathetic yet incisive eye, evoking melancholia and austerity, as he observed their solitary states and their traditional way of life.

[My aim was to] find again the village I remembered from my childhood and, with my camera, try to re-create the pattern of life, which in the 1930s and 1940s was still characterized by self-subsistency and mutual exchange of services."

Sune Jonsson

Home of an Italian Ragpicker, New York (1888)
Jacob Riis Museum of the City of New York, USA

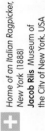

Bud Fields and His Family, Hale County, Alabama (1936)
Walker Evans

Gelatin silver print
Västerbotten Museum,
Umeå, Sweden

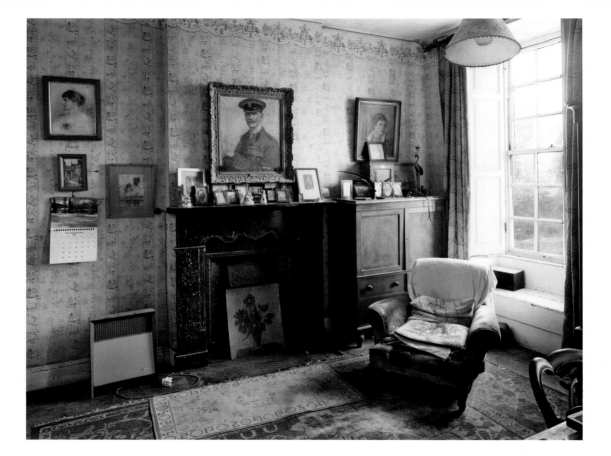

A House in Ireland, from the series *Bonnettstown*

1978–82 Andrew Bush

In this photograph, the room is described in great detail, and clues about its unseen inhabitants are laid through the pictures and objects that decorate it. It is a room that describes the past and has little connection with the modern world. Bush photographs the room as an inhabited space: an electric heater stands by the fireplace; the rugs are worn and faded; an armchair is padded and cushioned for comfort. Lit by the daylight from a large window, the photograph combines respect for the elegance and proportions of this Georgian living room with a lively curiosity about its inhabitants.

US photographer Andrew Bush was hitchhiking in Kilkenny, Ireland, in 1978 when he encountered one of the residents of Bonnettstown Hall. He returned to Kilkenny some months later and made the first of many visits to the manor house, making a series of photographs that document a way of life, as seen through interiors. There are no people in Bush's photographs of Bonnettstown, but the elderly inhabitants are nevertheless present in the photographs, described by their possessions, the arrangements of their rooms, and by signs of recent occupation.

I realized I had found a great subject in the remnants of a European aristocratic lifestyle, in four elderly people living together in the deteriorating splendor of a glorious estate."

Andrew Bush

Chromogenic print
Photographer's collection

Joe's Barbershop
(1970)
George A. Tice

House
(1975)
Kishin Shinoyama

Living-room in Stroud Green, London (c.1985)
Simon Butcher

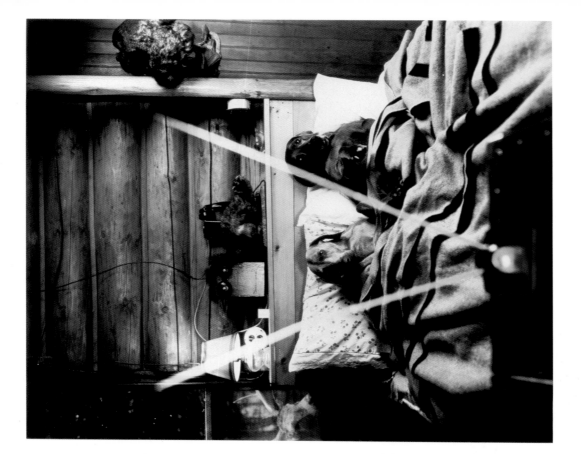

Ray and Mrs. Lubner in Bed Watching TV 1981 William Wegman

By posing his two dogs in a human situation, Wegman shifts the balance between fact and fiction, between the commonplace and the bizarre. Wegman's photograph portrays a moment of everyday life, and it succeeds not only because of its unexpectedness and humor, but also because it clearly uses canine models to tell a removed narrative of how humans behave as they move around the domestic landscape. The television aerial acts as a window onto this unusual world, fraught with oddity and surprise.

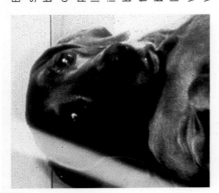

William Wegman's photograph of the Weimaraner dogs Man Ray and Mrs. Lubner forms part of an extensive series of posed dog portraits, made by Wegman since the early 1980s. Man Ray, who died in 1982, was Wegman's first canine model. This photograph is a domestic comedy that encourages viewers to look closely at their human selves, seen through the prism of the posing dogs. Wegman discerned "acting ability" in Man Ray and in all the dogs he subsequently used in his photographic series. Placing the two dogs in the domestic but rugged "all-American" setting of the cabin, Wegman portrays them as a couple at home, relaxing in bed watching the unseen screen of a television set.

It irked me sometimes to be known only as the guy with the dog, but on the other hand it was a thrill to have a famous dog.
William Wegman

Diffusion transfer print
Pace/MacGill Gallery,
New York, USA

Jack and Miriam Paar in Bed in Bronxville, Watching Jack's Show (1959)
Cornell Capa

"Dog With Sunglasses" from the series *Common Sense* (1998)
Martin Parr

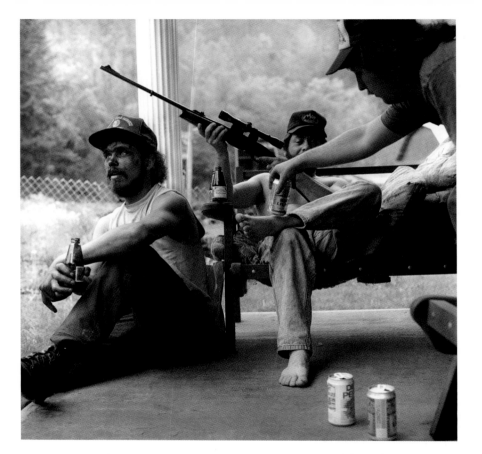

From the series *Grapevine* 1989
Susan Lipper

In the late 1980s, Lipper began a photo series in the small hamlet of Grapevine Hollow, West Virginia. She became fascinated by this insular, rural community and has visited it many times. This image is a study of masculinity in which Lipper emphasizes the physicality of exposed skin and tensed muscles. In the background is a treescape; delicate leaves form a latticework. However, Lipper repudiates the romance of the rural—the countryside she photographs is the setting for a cycle of deprivation, rather than the opportunity for an idyll.

Susan Lipper's use of formal, controlled documentary photography creates a dynamic structure for the composition. A considerable amount of content is enclosed within a tightly drawn frame. The angle of a gun is mirrored by the outstretched arm of one of the three men who appear to be relaxing at home—a hand gripping a can provides the perfect center for the image and a focus for the viewer. The figures at both edges of the photograph are cut off by the frame, adding fracture and urgency to the image. There is something inherently discordant and uneasy about this group of men—they are together, but each is marooned in his own intense sphere of activity.

A lot of my work is subjective documentary. So much of it is about the relationship between me and the subject."
Susan Lipper

Gelatin silver print
Photographer's collection

Roadside Stand near Birmingham, Alabama (1936)
Walker Evans

Seacoal (1983–84)
Chris Killip

Romania (1988)
Josef Koudelka

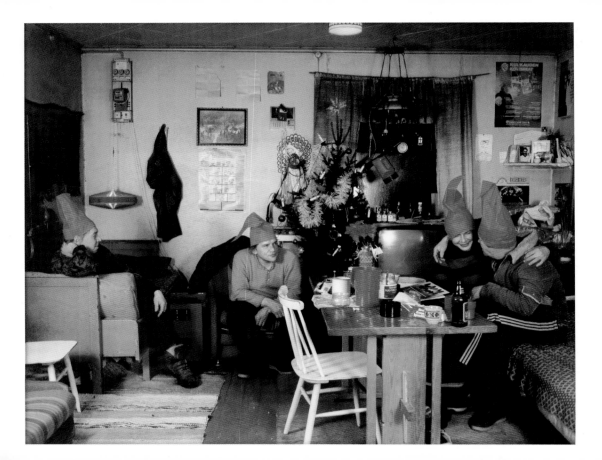

Kuivaniemi, Finland 1991
Esko Männikkö

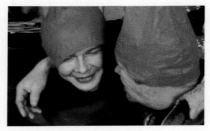

The strength of this photograph lies in Männikkö's precise description of this domestic scene, in which every object, every texture, and every pattern is clear, giving the viewer much information about the culture and lifestyle in Kuivaniemi. The walls of the room are a bricolage of pictures, documents, and everyday working objects. Männikkö establishes a tension in the photograph by comparing the couple who sits in front of the television with the two men who sit alone. Made in a region that is depopulated, and where many rural men do not marry, the photograph has considerable poignancy.

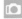

This photograph is one of a series, and it depicts a group of people celebrating Christmas at home in rural Finland. It is a subtle and empathetic study of both conviviality and isolation, of remote lives framed by the presence of the dark Finnish midwinter. Esko Männikkö saw the possibilities presented by this simple celebratory scene, and, like many of his photographs from this time, the power of the image lies in the combination of subject matter and setting, as well as a precise sense of timing. Männikkö describes the setting with great accuracy, noting the clumsily decorated Christmas tree, which sits strangely in an otherwise utilitarian room. The photograph has no center of interest; rather, everything within it is important and perfectly balanced.

You have to know the look you are after before you set out to take the photograph."
Esko Männikkö

Chromogenic print
Private collection

Christmas Dinner in Iowa (1936)
Russell Lee

Two Women, Lansdale, Arkansas (1936)
Margaret Bourke-White
Syracuse University, New York, USA

Västerbotten series
(1950s–60s)
Sune Jonsson

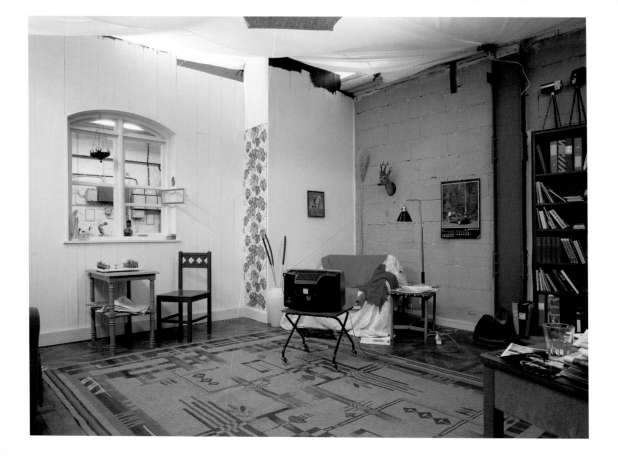

From the series *Set Constructions SO14* 1995–2000
Miriam Bäckström

HOME
REAL FICTIONS

This image has every appearance of a scene chanced upon, but it is as much a fiction as the scene it represents. Bäckström's photograph has a certain claustrophobia: the interior is revealed as a sham—its details and objects meaningless, except within the far-reaching remit of the television drama. This meticulously planned and carefully executed photograph is very much part of a series—photographs that depend upon and inform each other—but it succeeds equally well in its own right: laconic, simple, understated, yet completely memorable.

Swedish artist Miriam Bäckström is interested in the fictional "homes" constructed by museums and television production companies. She photographs them in the series *Set Constructions* as "real" interiors, but is careful to include the details that the television viewer would not usually see: in this photograph, the crumpled patched ceilings and the jarring intrusions of construction and artifice. Bäckström notes the shoddiness of the construction but also its verisimilitude, exemplified by the careful placing of domestic objects—a television set, chair, jumbled bookshelves, and cluttered surfaces. The interior suggests the presence of a solitary inhabitant but does not reveal any information about their identity.

I do not see a clear boundary between my reality and that of the image."
Miriam Bäckström

Cibachrome on aluminum
Nils Staerk Contemporary Art,
Copenhagen, Denmark

Untitled Film Still, No. 50 (1979)
Cindy Sherman
Museum of Modern Art,
New York, USA

Cousin Mimi and her Neighbour Do a Little Last-Minute Laundry (1982–88) **Suzanne Winterberger and Martha Friend**

Miss Mit (1993)
William Wegman

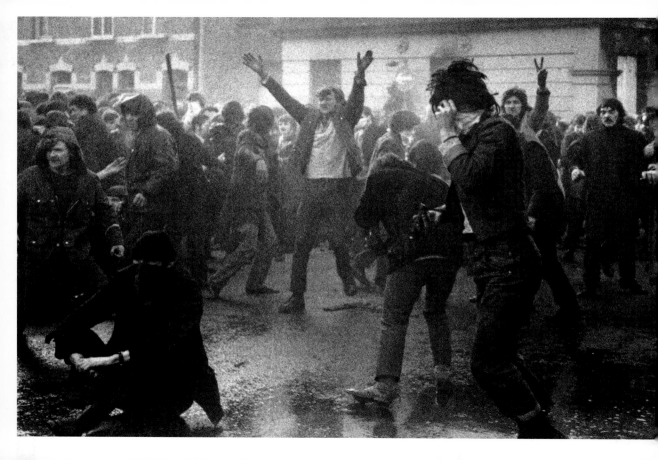

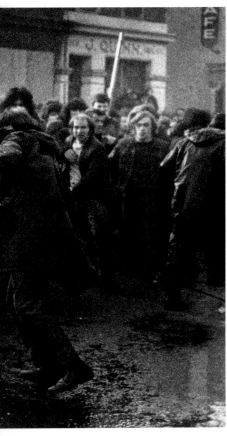

CONFLICT

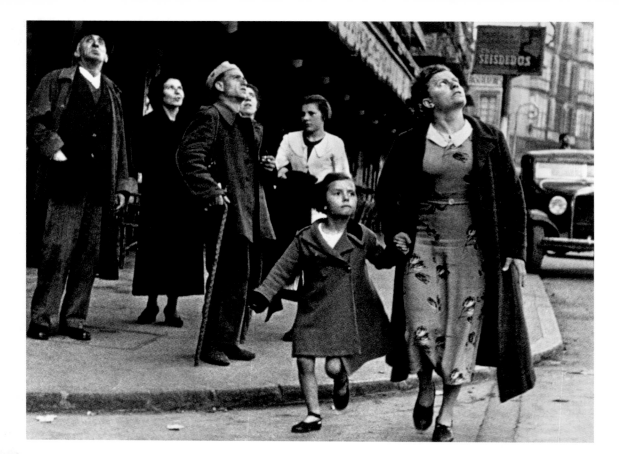

Looking at German Luftwaffe Pilots Flying Over the Gran Via, Bilbao, Spain 1936 Robert Capa

Capa made this photograph on a street corner, where he had observed people looking upward at enemy planes flying over Bilbao. The timing of the photograph is precise—a minute later and the group would have dispersed. The woman and child are the focus of the composition: both are vulnerable as they cross the road, but they are transfixed by the planes overhead. The group standing on the pavement is also concentrating on the ominous presence above. Bert Hardy, Walker Evans, and many other documentary photographers have used the street corner to create dynamic compositions.

Robert Capa's photograph was taken while he was reporting on the Spanish Civil War. He traveled to Bilbao and spent the early days of his visit photographing on the streets, observing citizens as they faced the threat of bombardment. The strength of Capa's photograph lies in its timing and location. More accustomed to making photographs in the midst of battle, Capa's simple, undramatic images, made on the streets of Bilbao, demonstrate how quickly he was able to adjust his photographic methods to suit the situations he encountered. His skill at capturing the moment would have been well honed by his experience in the fast-moving arena of conflict, and in this photograph, he brings it skillfully into play.

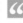

It's not always easy to stand aside and be unable to do anything except record the sufferings around one."
Robert Capa

Gelatin silver print
Photographer's collection

On the Street Corner (1948)
Bert Hardy

Loyalists v. Nationalists (1986)
Gilles Peress

Raising the Flag on Iwo Jima (1945)
Joe Rosenthal

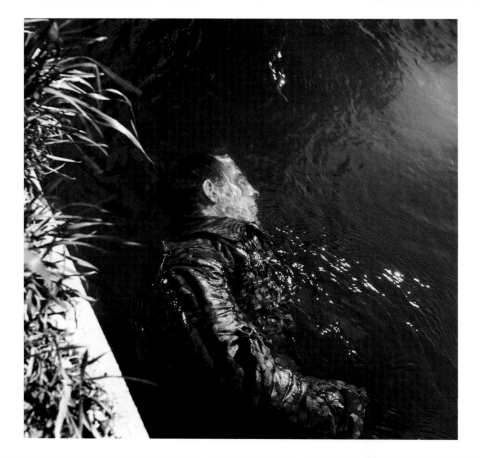

Dead SS Guard Floating in Canal, Dachau 1945
Lee Miller

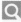

This otherwise pleasant environment is desecrated by violent death, by the decaying body that pollutes it. It becomes a symbol for the pollution of the European consciousness, which the Nazi concentration camps came to represent. Although the image is the result of a chance encounter, Miller took great care with its composition. She shoots at an angle, emphasizing the correspondence between the dead arm and the canal bank. It is a very beautiful image of an ugly scene, and thus becomes even more potent. The sunlight that illuminates the water adds to the pictorial quality, and to the ultimate impact of the image.

Lee Miller photographed the effects of World War II when she traveled around Europe for *Vogue* magazine in the mid-1940s. Unlike many of the photojournalists who photographed the aftermath, she was unaccustomed to the carnage of conflict, and her photo essays have an immediacy and rage that has ensured their continuing power. Like many of Miller's photographs from this time, this image is quiet and well composed, which makes it all the more shocking. The guard, still clad in his SS leather coat, floats undisturbed in the water. The body is not disfigured, the water is calm, and foliage flourishes on the bank.

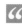

The first thing we noticed was there were no birds or animals. It was a bad sign. . . Then we came upon some dead SS troopers. They had been beaten or strangled."
Lee Miller

Gelatin silver print
Lee Miller Archive

Confederate Dead Behind a Stone Wall, Virginia (1863)
Andrew J. Russell

The Falling Soldier (1936)
Robert Capa
Museum of Modern Art,
New York, USA

Dead German Soldier, Western Desert, Egypt (1941)
George Rodger

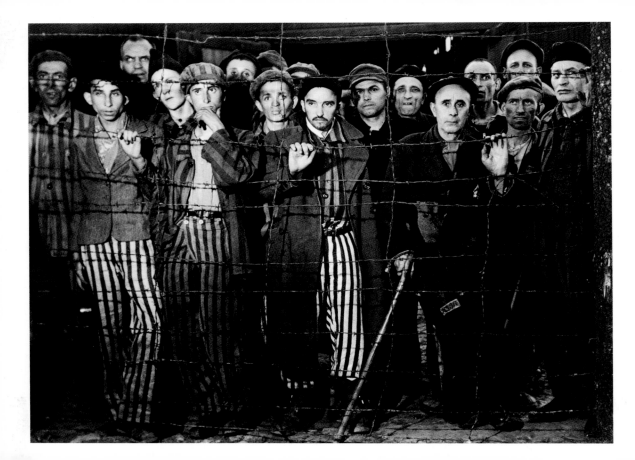

The Living Dead of Buchenwald 1945
Margaret Bourke-White

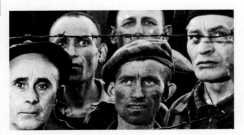

The Living Dead of Buchenwald is a close-up image with no foreground, allowing Bourke-White to tighten her composition so that no extraneous detail is included. The grid of wire cuts across the tragically clownish pajamas of the prisoners and represents the pain and suffering of those who experienced the concentration camps. There are only five full-length figures, but behind them are rows of faces, each severe, anxious, and depleted. In this one image, Bourke-White gives a large amount of information, demonstrating her photojournalistic skill.

Life magazine photojournalist Margaret Bourke-White was one of the many US photographers who bore witness to the liberation of the Nazi concentration camps at the end of World War II. She photographed this group of prisoners wearing the striped uniform now so symbolic of the Nazi predilection for order and discipline, even within the skewed realities of the camps. Bright lights illuminate the prisoners, giving their faces a pale radiance, while at the same time emphasizing the deformation of malnutrition. Central to the photograph is the barbed wire fence, which not only symbolizes imprisonment but also creates a grid, giving the photograph a tight and disciplined structure.

Nothing attracts me like a closed door. I cannot let my camera rest until I have pried it open."

Margaret Bourke-White

Gelatin silver print
Time & Life Archive

Children Playing in the Ruins, Spain (1934) **Henri Cartier-Bresson**
Museum of Modern Art, New York, USA

Freed Prisoners, Dachau (1945)
Lee Miller

Mau Mau Suspect Being Held, Nairobi (1954)
George Rodger

129

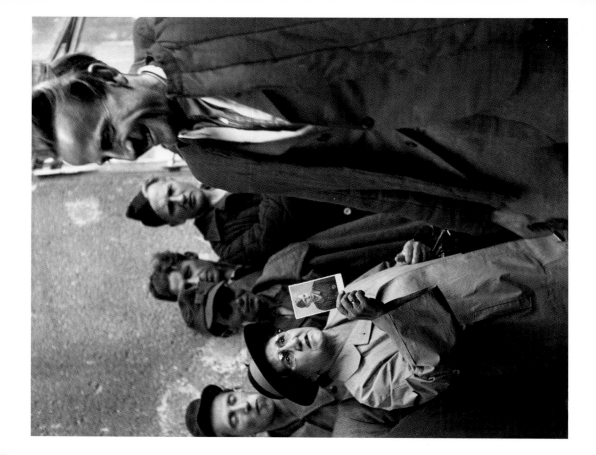

Homecoming Prisoners, Vienna
1947 Ernst Haas

Haas uses scale particularly well in this photograph. The returning prisoner is a large figure, occupying almost half of the image. In comparison, the small crowd is passive: only the woman displaying the photograph is active, and yet there is inertia, too, in her weary gesture. Haas apparently came upon this scene while walking through Vienna, and, if so, displayed remarkable photographic acumen and speed of reaction to make this moving image, which sums up the chaos of displacement and the aftermath of conflict.

Homecoming Prisoners, Vienna was Ernst Haas's first major photojournalistic essay. This photograph, from the series that Haas made in his native Vienna two years after the end of World War II, has a lasting power. Haas sets up a contrast in the photograph between the smiling face of the prisoner of war and the anxious expressions of the crowd that gathers on the left as one woman holds up a portrait of a missing relative. The neatly clad soldier in the backgound provides another contrast with the roughly attired returning prisoner, who is vigorous, striding, and intent on reaching his destination. The poignancy of this scene is clear, and—as in the best photojournalism—the message is immediate.

> *Best wide-angle lens? Two steps backward. Look for the 'ah-ha.'*
>
> **Ernst Haas**

Gelatin silver print
Photographer's collection

Gestapo Informer, Dessau, Germany (1936)
Henri Cartier-Bresson

A Sit-in In Front of the Ministry of Agriculture (1997)
Alex Majoli

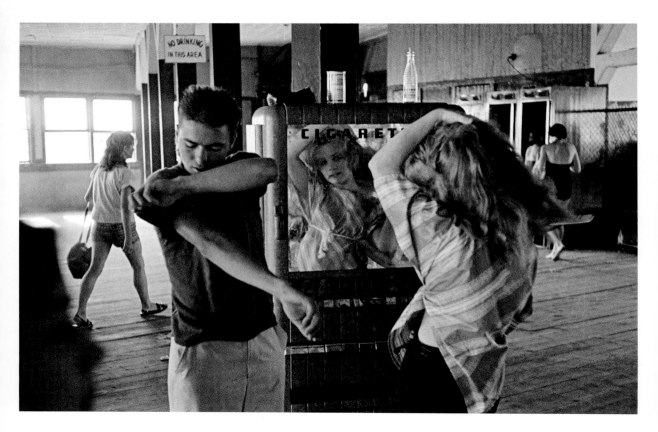

Kathy Reflected in Cigarette Machine, from the series *Brooklyn Gang* 1959 Bruce Davidson

CONFLICT
REFLECTION

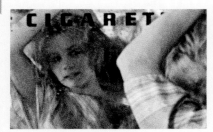

The core of the image is the reflection in the mirror. A young woman poses for her "mirror portrait" while also being fully aware of Davidson's camera. She meets the photographer's gaze, aware of her own beauty, confident in her self-posing. Beside her, a young man contorts his arms, and the juxtaposition of his arms, head, and body creates a kind of dissonant symmetry, which in turn mirrors the arched arm of the young woman. Behind the couple, two figures cross the background, giving flow and action to the photograph, which adds to the stillness and self-reflection of the main characters.

Bruce Davidson's emblematic series of photographs of young gang members in 1950s Brooklyn exposed a secret world of youth subculture to the public gaze. In 1957, the Broadway musical *West Side Story* examined the theme of gang conflict, which was of considerable public interest in a society that was attempting to understand the phenomenon of youth. Davidson's photographs tackle a similar theme, as they document an intricate, multicultural set of groups. This photograph, which is one of the best known of the series, sets out neither to glamorize nor demonize its subjects. Davidson captures perfectly the self-absorption of youth and its inevitable, unflawed beauty.

If I am looking for a story at all, it is in my relationship to the subject—the story that tells me, rather than that I tell."

Bruce Davidson

Gelatin silver print
Museum of Contemporary
Photography, Chicago, Illinois, USA

"Elkhorn, Wisconsin, USA"
from the series *Bikeriders* (1966)
Danny Lyon

*Heinas in a Ranfla,
Los Angeles* (1992)
Robert Yager

*John Faber Grooms Himself,
Calli, Colombia* (1998)
Paul Fusco

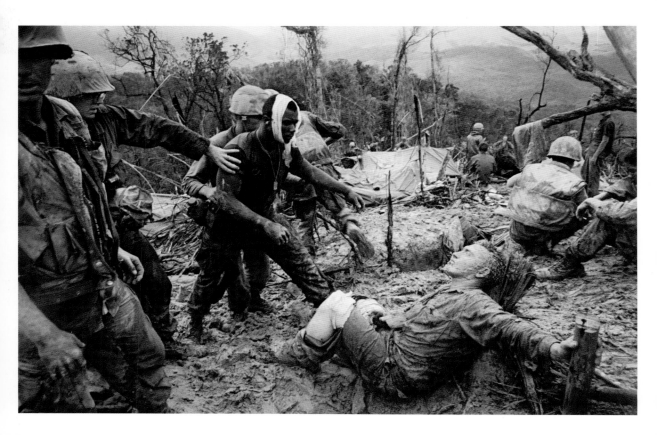

Mutter Ridge, Nui Cay Tri, South Vietnam 1966
Larry Burrows

This photograph is a finely composed study of injury and despair. The central figure, head bandaged, is restrained from helping his wounded colleague. The image is so effective because not only has Burrows photographed a moment of personal intensity, but he has also made a photograph that describes the environment of war: the sea of mud in which the first aiders work, the muddy paste covering the clothes, and one spot of color: a patch of blood oozing out from a dressing. Behind the first aid camp is the sublime Vietnamese rural landscape, again providing a counterpoint to the central focus of the image.

The first aid center that Larry Burrows photographed at Mutter Ridge treated wounded marines before they were evacuated, and it says much about Burrows's finely honed photojournalistic instincts that this scene, away from the conflict, says more about war than the most dramatic battle pictures. The men are frozen in time, figures in a tableau reminiscent of Francisco de Goya's *The Disasters of War* (1810–20). Burrows photographed war in order to prevent it, and this photograph is one of the many exemplary photojournalistic images that act as testament to the wasted lives, destroyed landscapes, and physical pain that so characterized the war in Vietnam.

I concluded that what I was doing would penetrate the hearts of those at home who are simply too indifferent."
Larry Burrows

Dye-transfer print
J. Paul Getty Museum,
Los Angeles, California, USA

Cushing's Battery at Antietam (1862)
Mathew Brady

Omaha Beach, D-Day (1944)
Robert Capa

General Nguyen Ngoc Loan Executing a Viet Cong Prisoner (1968)
Eddie Adams

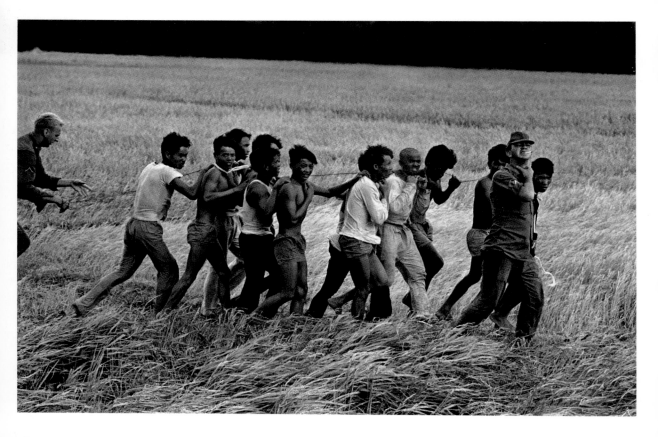

Soldiers With a Group of Captured Subjects, Quin Hon, South Vietnam 1967 Philip Jones Griffiths

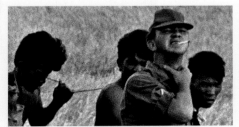

In this image, Jones Griffiths sets up a comparison between the poorly dressed prisoners and the well-equipped US soldiers. His photograph describes the way that the prisoners are herded across the landscape like animals, tethered together around their necks. The fear and panic of the captured men is in stark contrast with the nonchalance of the captors. To the left of the frame, a US soldier appears predatory, hands stretched out toward the prisoners, giving the image an added tension. Another soldier raises his hand to his throat, indicating choking.

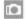

Magnum photojournalist Philip Jones Griffiths spent three years photographing in Vietnam, arriving in 1966, and his book *Vietnam Inc.* (1971) set a standard for the humanitarian documentation of war. Set against the lush grass of the Vietnam landscape, Jones Griffiths's image draws attention to the fact that the Vietnam War was a rural conflict, fought by a highly mechanized army against a peasant population. Although it appears to be such a simple photograph, Jones Griffiths uses it to convey complex information and, without using crude propaganda, makes his opposition to the US invasion of Vietnam very clear.

Not since [Francisco del] Goya has anyone portrayed war like Philip Jones Griffiths."

Henri Cartier-Bresson

Gelatin silver print
Steven Kasher Gallery,
New York, USA

Charleston Cadets Guarding Yankee Prisoners (1861)
George Cook Valentine Museum, Richmond, Virginia, USA

Exiled Republicans Being Marched Down the Beach to an Internment Camp, Le Barcarès, France (1939)
Robert Capa

Vietnam War, Laos, South Vietnam (1971)
Bruno Barbey

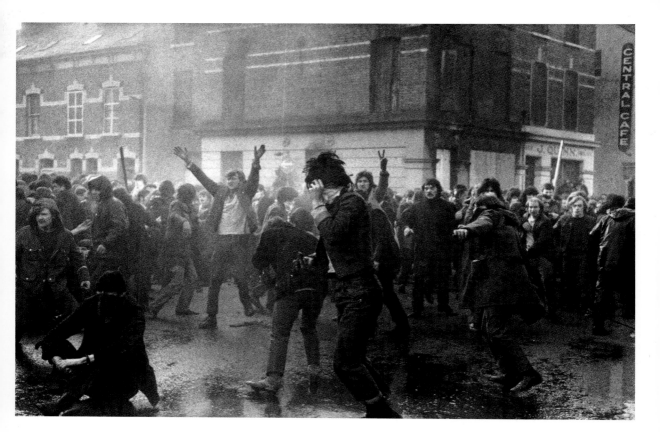

One Minute Before British Paratrooper Fires, Bloody Sunday, Derry, Northern Ireland 1972 Gilles Peress

CONFLICT
THE MOMENT BEFORE

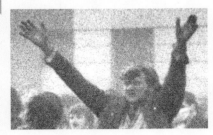

Many photojournalistic images were made of the scene of the shooting on Bloody Sunday, and the panic and fear that followed the attack, but this photograph of "before" is perhaps the most revealing. History records the subsequent events, but this image tells of the moment when history began to be made. Peress uses the streetscape to great effect: the buildings are domestic and undramatic, an unlikely setting for mayhem and death. He is also very aware of the foreground of the photograph—a small space is empty around the central figure, isolating him as messianic and seemingly inviolable.

Magnum photojournalist Gilles Peress arrived in Northern Ireland in 1972, at the peak of the period of conflict known as "The Troubles." In this photograph, he shows a large group of youths at the height of protest. Shortly afterward, the British army opened fire, killing thirteen people in a military action that has been the subject of debate to the present day. Peress places himself facing the crowd and captures the chaos and activity of the scene. Working with a 35mm camera, he focuses on a youth standing in the center of the crowd with arms outstretched. The young man's pose is defiant and confrontational in comparison to the figures that surround him, stoical and anticipatory.

I don't care so much anymore about 'good photography.' I am gathering evidence for history."

Gilles Peress

Gelatin silver print
Museum of Contemporary
Photography, Chicago, Illinois, USA

Adjusting the Ropes for Hanging the Conspirators (1865)
Alexander Gardner Library of Congress, Washington, D.C., USA

President and Mrs. Kennedy in Motorcade, Dallas (1963)
Otto Bettmann

A Young Rioter Prepares to Throw a Petrol Bomb (1981)
Peter Marlow

139

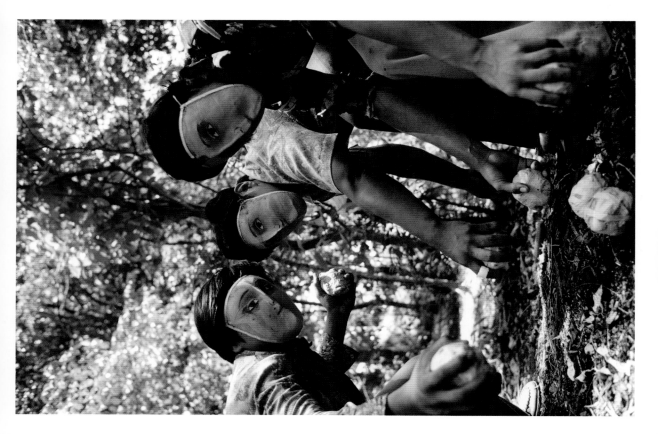

Youths Practice Throwing Contact Bombs in Forest Surrounding Monimbo c.1978 Susan Meiselas

Meiselas constructs a photograph that creates a beguiling narrative of masquerade. It is a photograph about disguise, as well as a socially and politically aware document that signaled a new kind of war reportage.

Photographed from a low angle, the figures become monumental, towering above the photographer like giants, their arms mirroring the tree trunks of the forest in the background. Color within the photograph is deep and rich, so that the image also acquires a kind of glamour not commonly associated with war photography.

This photograph first appeared in Susan Meiselas's monograph *Nicaragua* (1981), a series of photographs that document the country from the Somoza regime to the Sandinista revolution. *Nicaragua* avoids the clichés of conflict photography and instead is a complex, empathetic, and ultimately collaborative documentary work. This photograph gives information about the minutiae of training in this revolutionary army, and about the environment in which the training took place. The masks worn by the youths give the image unity; the young soldiers become depersonalized warriors in costume—mythic and unknowable.

> *The camera is an excuse to be someplace you otherwise don't belong. It gives me both a point of connection and a point of separation."*
>
> Susan Meiselas

Masked Men Hurling Molotov Cocktails (1981)
Ian Berry

Demonstration Against the Government's Bailout Plan in Lower Manhattan (2008)
Gilles Peress

Chromogenic print
San Francisco Museum of
Modern Art, California, USA

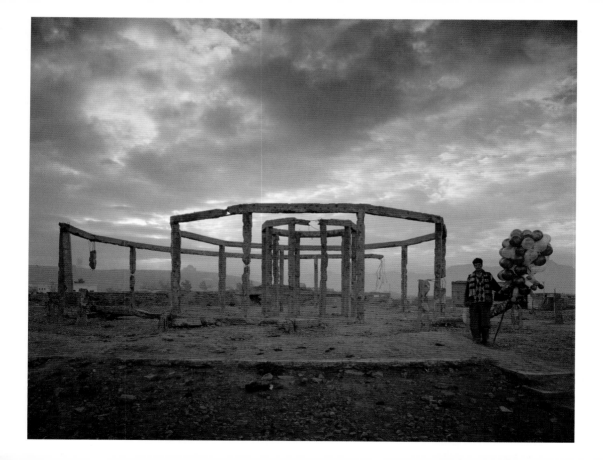

Former Teahouse in a Park, Kabul 2001–02
Simon Norfolk

This photograph shows a balloon seller standing next to the ruins of a teahouse in Kabul, Afghanistan. Banned by the Taliban, balloons have emerged as one of the symbols of freedom from authoritarian rule that Afghans celebrate. The irony of the photograph is obvious: a shattered structure of pleasure in a bare and scarred landscape, the brightly colored balloons representing pleasure and play. Norfolk began to use color photography when he worked in Afghanistan, and used a 5 x 4 field camera to add detail and tone to his images.

Simon Norfolk photographs "spaces and environments that are created by warfare and the need to fight warfare," and his images are driven by deep political, philosophic, and artistic concerns. Although his work is now firmly positioned within the art world, he began his career as a photojournalist. He makes sublime and beautiful photographs in conflict zones, spending extensive periods of time in one location, combining the methodology of the photojournalist—access, contacts, self-preservation—with the sensibilities of the artist—meditative, philosophical—and a continuing outrage with the politics of warfare.

Part of this interest of mine in the sublime means that a lot of the artistic ideas that I'm drawing on partly come out of the photography of ruins."

Simon Norfolk

Pigment print
National Media Museum,
Bradford, UK

Timur Shah's Mosque (1879)
John Burke

Nuremberg (1945)
Margaret Bourke-White

Women in Burkas, Kabul, Afghanistan (1994)
Chris Steele-Perkins

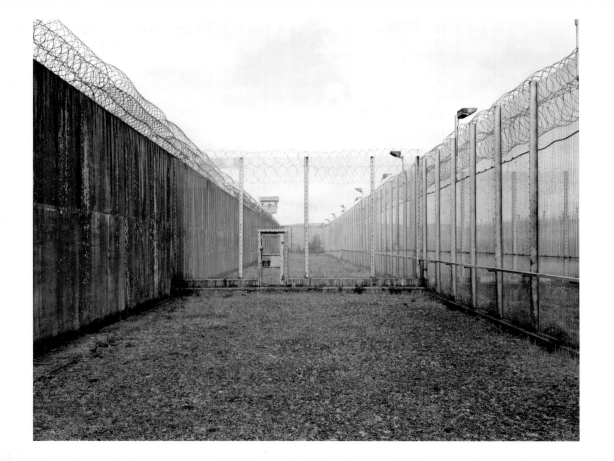

The Maze Prison, Sterile, Phase 1 2003
Donovan Wylie

Wylie's photograph of a sterile zone in the Maze Prison shows a vast, bisected space that seems to extend infinitely. Constructed on one side of the inner fence, the zone ran along the whole length of the prison and was designed to immobilize escaping prisoners. In this photograph, Wylie has conveyed the immensity of these spaces and their symmetry, bounded on each side by near-identical structures of metal wall and barbed wire. His use of photographic references from the past and his ability to convey the hugeness of the space contribute to the power of this image.

Donovan Wylie's photograph is from a two-part series made at the empty Maze Prison in Belfast, and at first sight this image seems dispassionate, a study of the architecture of confinement. However, for Belfast-born Wylie, the prison expressed a personal claustrophobia. His treatment of the prison buildings in the series references nineteenth-century photography, and his admiration for the work of Walker Evans and Eugène Atget is clear. From early photographs comes a sense of bleak, uninterrupted space; from Atget and Evans a calm and objective appreciation of materiality.

> *I realized that the prison was a machine, a piece of architecture designed to do a job. Literally and conceptually it was designed to capture men, so I started to shoot it like that."*
> **Donovan Wylie**

Pigment print
Photographer's collection

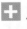

Slave Houses on "Hermitage" Plantation, Savannah, Georgia (1935)
Walker Evans

From the Watch Tower (1976)
Jean Gaumy

Recreational Court, Guard and Prisoner (1998)
Raymond Depardon

THE UNEXPECTED

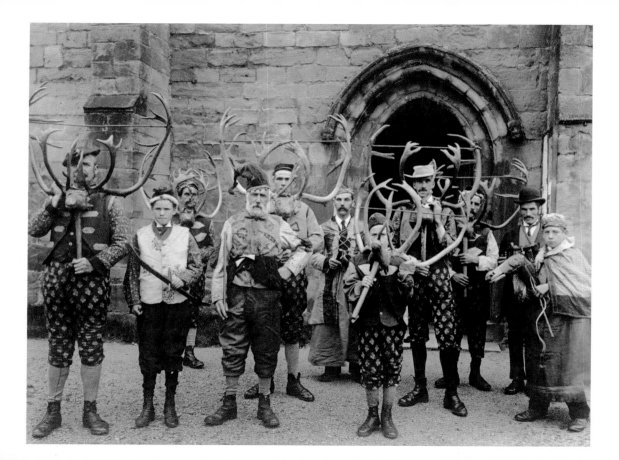

The Players in the Abbots Bromley Horn Dance *c.*1900
Sir Benjamin Stone

There is an incongruity in this scene that invites reflection. Despite the seriousness of the occasion, each of the subjects emerges as an individual, conscious of his presence within the group. Set against the stone wall and doorway of a church, the composition acquires even greater solemnity, suggesting history and tradition. However, there is also an inherent sense of comedy in this photograph, when seen through modern eyes. The players gaze into the lens wearing pairs of antlers and holding wooden hobby horses. Without exception they are immensely serious as they participate in the photograph.

Published in *Pictures—Festivals, Ceremonies and Customs* in 1906, this photograph is part of a wider survey made by Sir Benjamin Stone, a highly skilled amateur photographer, of folk traditions and rituals in England at the turn of the twentieth century. Despite its age, the photograph has a modernity that has appealed to many contemporary documentarists. It is a laconic image, in which the subjects are highly conscious of the camera. Stone's work enjoyed a revival in the 1970s, when many young British photographers took it as an inspiration and guide for their own photographic journeys around Britain.

> *Observe that the deer are evidently the deer of the lords of the manor, marked with their coats of arms, while the dance is the common act of the villagers as a body."*
> **Sir Benjamin Stone**

Platinum print
Benjamin Stone Collection,
Birmingham Archives and Heritage,
Birmingham, UK

Mudmen Tribe Gathers for Celebration of a Pig Killing, New Guinea (1970)
Burt Glinn

Day of the Dead, El Salvador (1985)
Jean Gaumy

Indian Chief, New Orleans, Louisiana (2006)
Christopher Anderson

A Monastic Brothel 1931
Brassaï

In *A Monastic Brothel*, Brassaï creates a distance between himself and the subjects by paying great attention to the checkered tile floor and the stone arches in the background. Bright light shines on the column of the arch, whereas everything else is in shadow. The woman is photographed from behind, but her client is clearly visible, making one figure simply form and the other an identifiable character. By using this straightforward device, Brassaï not only creates a certain mystery, but also makes a comment about an intimate relationship that is based on commerce and trade. Brassaï used the methodology of documentary photography to make photographs that were highly crafted and constructed, enabling him to translate his vision of Paris by night into photographs of the "real" world.

Hungarian photographer Gyula Halász adopted the name Brassaï when he began photographing in Paris in the mid-1920s. He was part of a close-knit circle of artists based in Montparnasse, all of whom were crossing boundaries between fact and fiction in their work. Brassaï's first major photographic project, *Paris by Night*, was published in book form in 1933, and is an exploration of the city's raffish underworld, regarded as one of documentary photography's classic publications. *A Monastic Brothel* is a quiet, simple photograph, capturing a private moment of conversation between a prostitute and her client. Although Brassaï's images often appear candid, he openly admitted to staging some of his photographs. It is possible, therefore, that this image was arranged by the photographer as a reenactment of a familiar scene.

There are many photographs which are full of life but which are confusing and difficult to remember. It is the force of an image that matters."

Brassaï

Gelatin silver print
Private collection

Lovers With 3-D Glasses at the Palace Theater (1943)
Weegee

Kiss by the Hôtel de Ville (1950)
Robert Doisneau

Goya Fashion 1940
Horst P. Horst

The two socialites in *Goya Fashion* model matador hats, establishing an ironic dialogue with the Spanish work of art below. Francisco de Goya's art is somber and references violence, poverty, and conflict, whereas the models and their hats represent high society and introduce an element of frivolity. The women are not looking at the artwork but using it rather carelessly as a prop. The precise lighting, which highlights key elements, and the use of the work of art create an imagined stage.

Juxtaposition is a powerful tool of photography, used to compare and contrast subjects, emphasizing their similarity or dissimilarity. Here, Horst P. Horst sets up a conflict between the European social documentary of Spanish artist Francisco de Goya and the mores of US high society. He uses the Goya image not only to add gravitas to the photograph, but also to inject absurdity into the composition. The background is lit in a way that evokes a monumental, lowering sky. In front of this stand two society hostesses, both of whom have their arms folded, suggesting a disengagement with the artwork.

The elegance of his photographs . . . took you to another place. The untouchable quality of the people is really interesting . . . it's like seeing somebody from another world."

Bruce Weber
photographer

Gelatin silver print
Horst Estate, Miami,
Florida, USA

Dovima With Elephants (1952)
Richard Avedon
Museum of Modern Art,
New York, USA

Picnic at Glyndebourne
Opera (1988)
Chris Steele-Perkins

The Critic 1943
Weegee

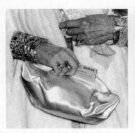

The Critic is all about contrasts: the two rich women wearing sumptuous furs and jewels, and the lone poor spectator huddled in a shabby overcoat. One of the women daintily clasps her satin evening bag, watched by the disheveled woman firmly clutching her bag to her chest. Weegee's trademark use of powerful flash illuminates the operagoers, making their faces white and waxy and adding sparkle to their expensive jewels and luster to their fine furs.

Weegee was the consummate press photographer and is well known for his indefatigable pursuit of stories. *The Critic* was taken on November 22, 1943, and appeared in *Life* magazine. It was originally titled *The Fashionable People,* and rumor has it that the unexpected grouping of the trio was engineered by the photographer, who persuaded a drunken woman from a Bowery bar to stand next to Mrs. George W. Kavenaugh and Lady Decies as they walked the red carpet. Weegee cropped the image to leave only the central three characters, making a powerful image about the gap between rich and poor.

News photography teaches to think fast, to be sure of yourself, self-confidence. When you go out on a story, you don't go back for another sitting. You've got to get it."
Weegee

Gelatin silver print
J. Paul Getty Museum,
Los Angeles, California, USA

The Steerage (1907)
Alfred Steiglitz
Whitney Museum of American Art,
New York, USA

Dovima With Elephants
(1952) **Richard Avedon**
Museum of Modern Art,
New York, USA

Child With Toy Hand Grenade
(1962) **Diane Arbus**
Metropolitan Museum of Art,
New York, USA

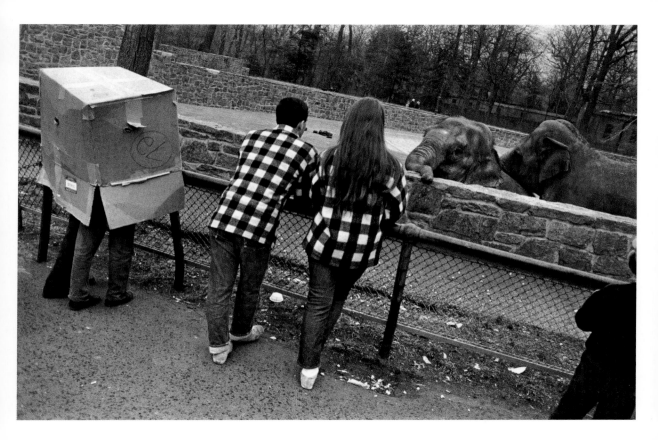

From the series *The Animals* 1969
Garry Winogrand

Winogrand was adept at capturing the dislocation and incongruity between people, location, and event. Of all the participants in the composition, only the elephant in the foreground is making some kind of connection. Captive and gazed upon, the elephant looks the photographer straight in the eye, and the viewer is disconcerted by its indirect, languid stare. The exploratory trunk reaches over the brick wall toward both the viewer and the two central spectators with their backs to the camera.

Garry Winogrand was a master of spontaneity, and his series of pictures showing the relationship of people to captive animals is both witty and disconcerting. This image is taken at a tilted angle, which emphasizes the scene's incongruity, and its focal point is the figures in the box. They are in disguise and hiding, but from whom? Using a wide-angled lens, Winogrand establishes the interconnectedness between the couple wearing identical checked jackets, the casual curiosity of the elephants, and the figures, bizarrely, inside the cardboard box. The comedy of the photograph is built around the oddness of humans, rather than the exotic nature of zoo animals.

Photography is not about the thing photographed. It is about how that thing looks photographed."
Garry Winogrand

Gelatin silver print
Private collection

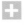

Square du Vert-Galant (1950)
Robert Doisneau
Gruber Collection

Daytona Beach (1990)
Carl De Keyzer

Fashion Shoot for Amica (1999)
Martin Parr

THE UNEXPECTED
EXPRESSION

Chelsea Flower Show 1975
Ian Berry

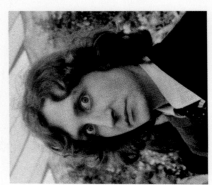

The young man whom Berry places at the center of the composition is very different from the more homely people who surround him, which makes him seem out of place. Like an Edwardian dandy, he is aware of his dress and body, and he is aware of the photographer, too, as his eyes meet Berry's gaze with a level and amused stare. Surrounded by foliage and passersby who are oblivious to the photographic act that is taking place, the subject of the photograph is an island of elegance, caught in mid-pose.

Ian Berry made this photograph as part of his 1970s series *The English*. Although documentarists usually photograph subjects when they are least aware of the camera's presence, on this occasion, Berry broke one of photojournalism's golden rules to make an image that has humor and presence. This opportunistic photograph is an example of the way in which photojournalists use everyday situations to make images that encapsulate time and place. Berry was able to calculate light, pose, and surroundings in a short period of time, making this memorable image before the crowd moved on.

> *The great single picture is emotionally satisfying, whereas getting a good journalistic story is more about being a professional."*
>
> **Ian Berry**

Gelatin silver print
Photographer's collection

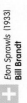 *Eton Sprawls* (1933)
Bill Brandt

 The Guv'nors, Finsbury Park, London (1958)
Don McCullin

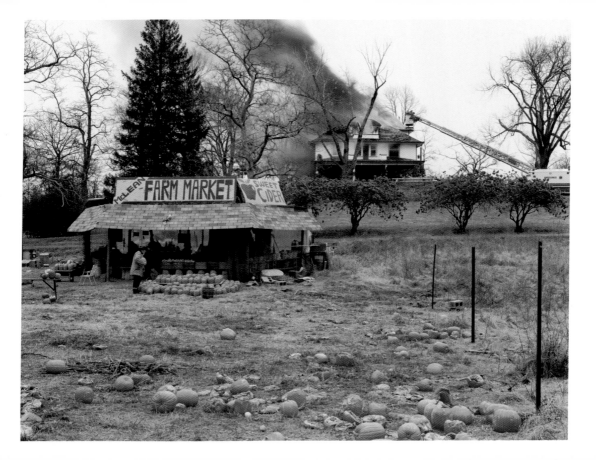

McLean, Virginia 1978
Joel Sternfeld

The combination of the fireman buying a pumpkin, the rundown farm stall, the blazing building, and the ruined fruit produces an enigmatic and mysterious image. It is a puzzle that engages the imagination. Sternfeld divides the composition into thirds—the fire, the stall, and the fruit in the foreground—giving equal importance to each, but at the same time providing a visual structure that is highly disciplined. He creates an image of a dramatic situation in which everything is static and flat, challenging conventions about the portrayal of place and event.

One of the primary new US colorists of the 1970s, Joel Sternfeld instigated new ways of portraying the marginal landscapes of the United States, focusing on "the ordinary," suburbia, and peripheral consumerism. In the 1970s and 1980s, Sternfeld used an 8 x 10 camera, enabling him to capture maximum information and present it in the clearest possible way. In this unexpected scene, a fireman selects a pumpkin from a farm stall, while behind him a building blazes. In the foreground lie shattered and discarded fruit. The color palette is subdued, with the flames of the house fire the only brightness.

> *Because photography has a certain verisimilitude, it has gained a currency as truthful—but photographs have always been convincing lies."*
>
> **Joel Sternfeld**

Dye-transfer print
Museum of Modern Art,
New York, USA

Moslem Praying Toward Mecca (1974)
Marc Riboud

"Grandmother, Brooklyn" from the series *Americans We* (1993)
Eugene Richards

Young People Relax along East River September 11, 2001 (2001)
Thomas Hoeckler

From the series *21st Century Types* 2005
Grace Lau

These modern, assertive women are in direct contrast to the decorous antiquarian decorations of sedate nineteenth-century China. They are slightly skeptical about the process of being photographed in such an unusual situation, but have clearly become part of the mystifying process of the photographic portrait. Although the rationale of the series was, in part, to explore notions of "orientalism" and the position of the "exotic" within Western culture, these concerns are overridden by the sheer presence of these young women and by Lau's skill in portraying them as citizens of the modern world.

In 2005, Grace Lau opened a free portrait studio in the seaside town of Hastings. Her customers included tourists, residents, and friends, attracted into the oriental-style studio by various fliers, press notices, and word of mouth. This image, of four young women bound for the beach, works on a number of different levels. Photographed in a formal pose against a painted backdrop, the subjects have all the dignity of the nineteenth-century women whose portraits can been seen in numerous albums from the past. Their accessories—sunglasses, sandals, handbags—highlight the discrepancy between their contemporary appearance and the traditional portrait setting.

The question of cultural representations in the archive is highlighted through my constructed tableaux and conflation of history."

Grace Lau

Chromogenic color print
Photographer's collection

The Shop on Greame Street (1972)
Daniel Meadows

Butlin's by the Sea (1972)
Martin Parr

Free Portrait Studio project (2010–11)
Jason Wilde

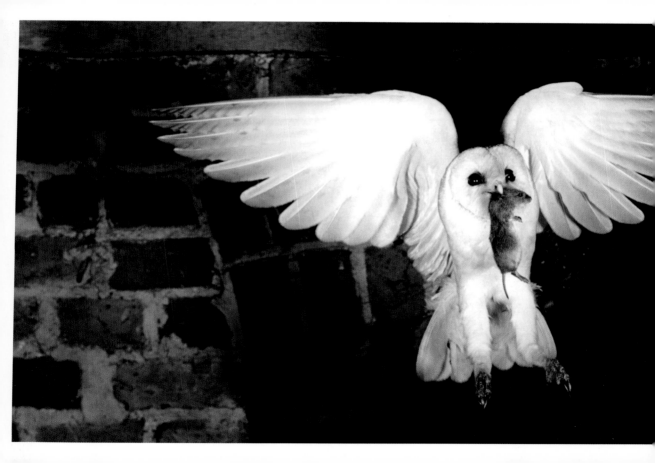

MOVEMENT

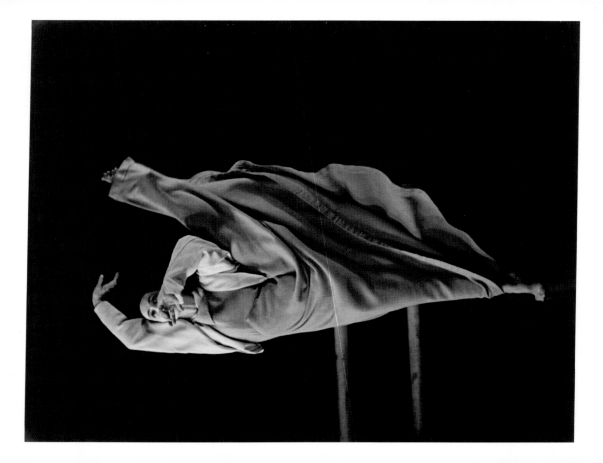

Martha Graham, Frontier 1935
Barbara Morgan

Morgan saw the use of light and shadow as being central to capturing form in dance photography. In this photograph of Martha Graham, the dancer's figure is brightly illuminated against a richly toned dark background. A sculptural presence, Graham becomes a series of shapes and planes, a moving body stilled, like a marble form. Morgan's photograph is an outstanding combination of technical skill and imaginative vision. Using one art form to portray another is remarkably complex.

One of the United States' foremost photographers of contemporary dance, Barbara Morgan was well aware of the technical and aesthetic challenges of photographing a subject in motion. She knew that dance was fluid and that photography excelled at freezing a moment in time; her challenge was to synthesize the two. Central to her success was her abundant use of light sources—photographic spotlights, floodlights, multiple flashlights—and an understanding that "the form of a moving subject is altered not only by its own changing shape, but by the interpretation imparted by camera timing."

> *Two fundamental things are always a source of wonder to the photographer of dance: the dancer's imagination and the latent powers of light by which beauty and meaning can be expressed.*
> **Barbara Morgan**

Gelatin silver print
Barbara Morgan Archive,
New York, USA

Margot Fonteyn in Swan Lake (1945) **Gordon Anthony** Victoria & Albert Museum, London, UK

Mikhail Baryshnikov and Rob Besserer (1990) **Annie Leibovitz**

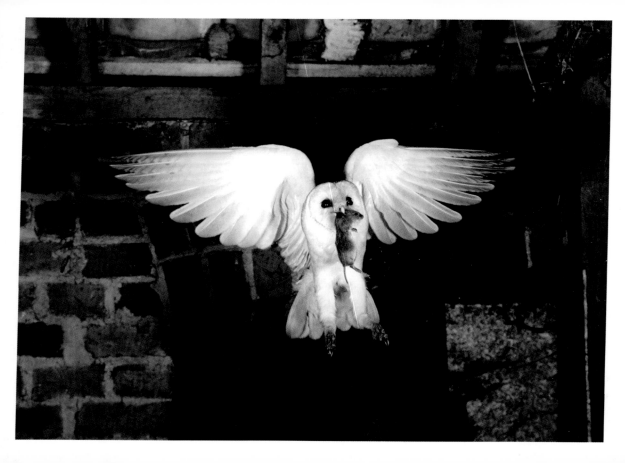

Barn Owl 1948
Eric Hosking

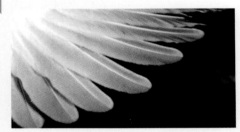

The owl, with its wings stretched wide, seems suspended in midair, as the photograph arrests movement. Hosking was able to make many photographs of this barn owl in flight because it was nesting in a grain hopper and its only access to its nest was through a small window. He arranged an automatic trip device in a series of slightly different positions and used a high-speed electronic flash. This meant that natural lighting no longer dictated what kind of photograph could be made, and that a series of images of the bird in flight was possible.

Barn Owl is one image from a series taken in quick succession in a Suffolk barn. Eric Hosking had been making photographs of birds since the early 1930s and was a highly skilled technician. He was one of the first photographers to experiment with flash to photograph birds. The success of the *Barn Owl* series lies in the fact that it is more than a record of bird life. Seen against the homely brick of a country barn, the owl in motion is magnificent, glamorous. In a Britain that had only emerged recently from World War II, the owl symbolized the sublimity of English nature, and photographing the bird in flight perhaps even paid an unconscious tribute to the wartime airmen who had flown in defense of Britain.

Not only is the wing frozen, but every feather, every barbule is stopped to show the beauty of line and function."
Eric Hosking

Gelatin silver print
Photographer's collection

Storks in Flight (1884)
Ottomar Anschütz
Agfa-Gevaert Foto-Historama,
Cologne, Germany

Henri Matisse's Studio (1951)
Henri Cartier-Bresson

Central Park, New York (1992)
Bruce Davidson

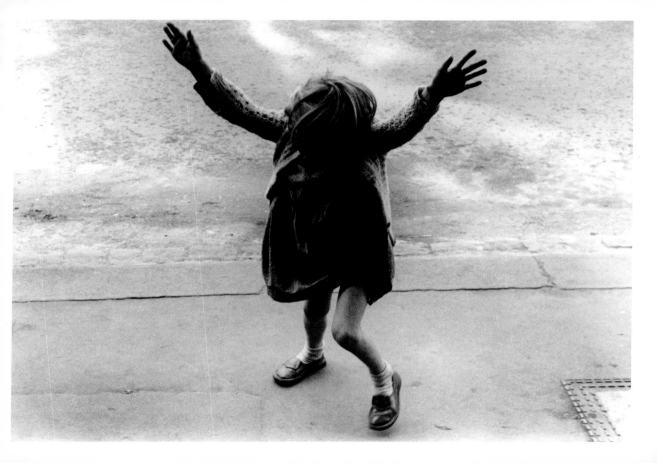

Girl About to Do a Handstand, from the series
Southam Street 1957 Roger Mayne

Mayne photographs his subject in shadow—faceless, she becomes pure form. As the girl prepares to launch herself onto her hands, she stretches her arms up to the sky, becoming a shape, arrested in movement. Mayne uses the space around the child, and the bisecting of the curb, to great effect: it is as if she floats in space, oblivious to onlookers, lost in concentration. The image succeeds because it marries several elements. Mayne isolates the child so that the viewer has no distractions. He captures the "moment before" and lets viewers imagine what comes afterward. His sense of urban space and his exclusion of extraneous detail make this a powerful image, full of life and energy.

Roger Mayne made some 1,000 negatives of the Southam Street area between 1956 and 1961. Part of London's postwar slumland, Southam Street was demolished in the early 1960s; Mayne's energetic documentary photographs are its monument. The series portrayed street life in all its variants—women and children, youths on street corners, girls parading—but the images of children are the most dynamic.

Photography involves two main distortions— the simplification into black and white and the seizing of an instant in time. It is this particular mixture of reality and unreality, and the photographer's power to select, that makes it possible for photography to be an art."

Roger Mayne

Gelatin silver print
Victoria & Albert Museum,
London, UK

Handstands (c.1900)
Heinrich Zille

*Tic-Tac Men at
Ascot Races* (1935)
Bill Brandt

New York City (1966)
Lee Friedlander
Museum of Modern Art,
New York, USA

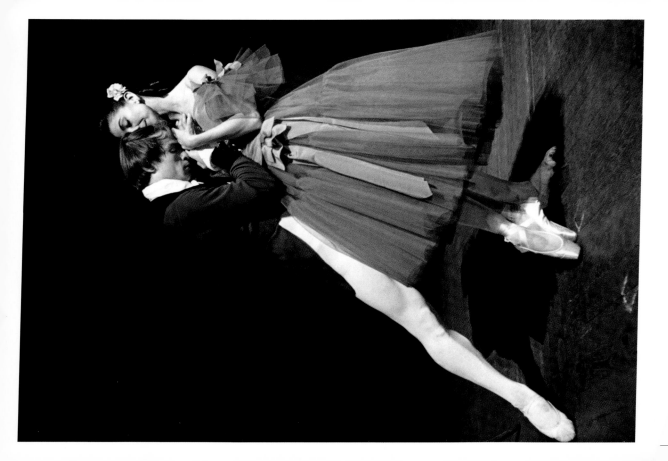

Margot Fonteyn and Rudolf Nureyev 1963 Eve Arnold

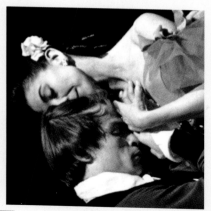

The image concentrates on the physicality of Fonteyn and Nureyev, and on the contradictory stance they share. Fonteyn leans backward, frail in the embrace of Nureyev, while he rests his head on her shoulder in supplication. As the more experienced dancer, Fonteyn supported Nureyev in his early career, but Nureyev's youth, talent, and strength were also vital for the older dancer. It is this relationship of need and support that this image captures so well.

The relationship between Margot Fonteyn and Rudolf Nureyev, both onstage and off, caused immense public interest, and choreographer Frederick Ashton created a ballet—*Marguerite and Armand*—specifically for them. This image has all the qualities of a well-lit dance photograph, but Eve Arnold also used her photojournalistic instincts, capturing the intensity of the relationship between the dancers and creating a highly newsworthy image. She was one of the first photographers to capitalize on the public's interest in the personal lives of well-known people; her access to Fonteyn and Nureyev plays an important part in the success of the photograph.

> *You can't make a great musician or a great photographer if the magic isn't there."*
>
> **Eve Arnold**

Gelatin silver print
Photographer's collection

Martha Graham: Letter to the World (Kick) (1940)
Barbara Morgan

Two Men Dancing (1984)
Robert Mapplethorpe

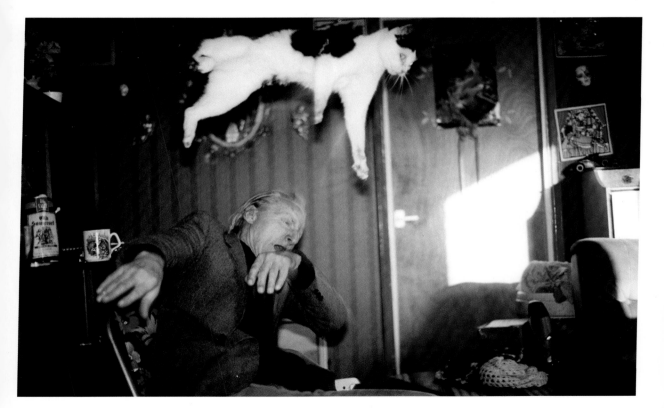

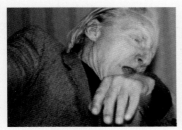

Billingham photographed his family for many years, and his proximity and familiarity made it possible for him to record the minutiae of their everyday life, including this remarkable moment of movement and surprise, in which Ray has thrown the cat up into the air in a fit of annoyance. The tilted angle of the photograph gives the impression of a snapshot, infusing the image with an immediacy and unexpectedness that startle and provoke. A single patch of sunlight illuminates the scene—its brightness at odds with the musty and cluttered interior—and an assorted medley of furniture and possessions provides the backdrop to the cat's flight.

Richard Billingham is an artist who is well aware of the nuances of visual culture, and his lengthy study of his family is built upon familiarity and access. It is "family photography" of a remarkable kind, made in the chaotic interior of the family's council apartment. The two central components of this image are Billingham's father, Ray, who suffered from chronic alcoholism, and the family cat, who appears to be flying across the room. Ray's hands are positioned directly below the cat, so that man and animal seem to act in unison, in some strangely choreographed ballet.

I was shocked when I realized that people can't read photographs. . . . People weren't seeing any beauty underneath, none of the composition, none of the pattern."

Richard Billingham

Color photograph mounted on aluminum
© Richard Billingham / Courtesy Anthony Reynolds Gallery, London, UK

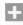

The Ballad of Sexual Dependency (1979–86)
Nan Goldin

"Three Little Girls in Gingham Dresses Hoovering the Lawn" from the series *Living Room* (1987–94)
Nick Waplington

"Practicing Golf Swing" from the series *Pictures from Home* (1992)
Larry Sultan

OUTSIDE

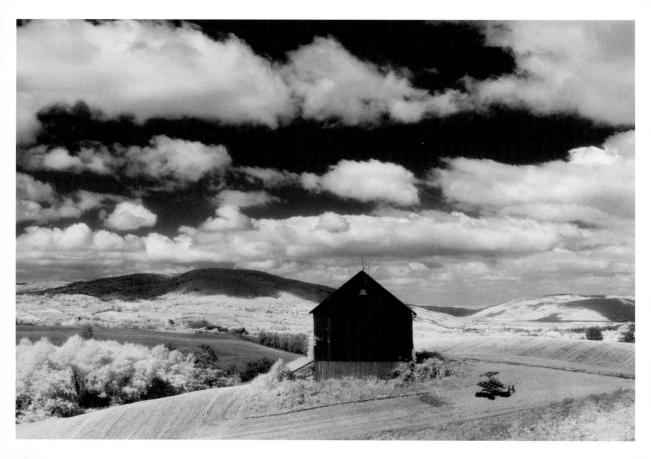

Vicinity of Naples, New York 1955
Minor White

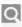

Minor White regarded subject matter as a metaphor for emotional understanding. Placing the building center frame, he uses it as a meeting point for the flowing diagonals and curves of the surrounding hills, presenting a precise manifestation of his interest in the confluence of the mystic and the material. *Vicinity of Naples, New York* was almost certainly made using infrared black and white film stock, which produced the startling negative appearance of the printed image. The landscape appears to be snow-covered, and the white barn becomes black.

Like his close friend and colleague Ansel Adams, Minor White planned his photographs carefully, visualizing each one and planning every shot with a meticulousness that stood in direct opposition to the idea of documentary and the photojournalistic opportunity. He often photographed mundane objects or outdoor scenes that were rendered beautiful by the quality of light. Although White's photography became unfashionable after the 1970s, when both his personal philosophies and technical methods were seen as labored and overstated, his work epitomizes a moment in photography when technique matured and became, once more, the central element of fine photography.

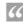

No matter how slow the film, spirit always stands still long enough for the photographer it has chosen."

Minor White

Gelatin silver print
Minor White Archive,
Princeton University,
New Jersey, USA

*Monolith, The Face of Half Dome,
Yosemite Valley* (1927)
Ansel Adams

Two Trees on a Hill With Shadows
(1947) **William A. Garnett**
Daniel Wolf Collection,
New York, USA

Point Lobos Wave (1958)
Wynn Bullock
Robert E. Abrams Collection,
New York, USA

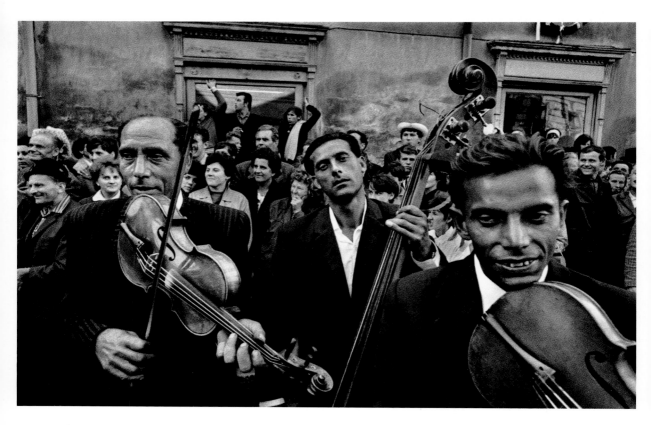

Straznice, from the series *Gypsies* 1965
Josef Koudelka

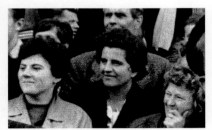

Like his fellow Magnum photographer Henri Cartier-Bresson, Koudelka was able to make precise choreographies from real-life situations. The musicians in the center of the photograph form an arc, behind which the members of the crowd become background. Koudelka makes it clear where he wants viewers to look, and what he wants them to see. "Straznice" is an enigmatic photograph—the crowd members are not looking at the band; instead they stare and gesticulate at a more distant event. The band's presence seems incongruous, giving the image a complexity that fixes it in the imagination.

Josef Koudelka began photographing East European gypsies in the early 1960s. He also produced a memorable series of photographs of the invasion of Prague in 1968. Like most documentary photographers of the time, Koudelka used a Leica camera because it was light and inconspicuous, and therefore enabled him to mingle with the crowd unobserved. The three men in the foreground are fixed, immobile, stranded by photography in a perfect moment. Koudelka has, in effect, skillfully made two equally intriguing photographs meld into one: the inner trio of figures and the encircling halo of the crowd become a perfectly balanced composition.

I believe that the truly creative periods are those when you live with intensity. If you lose intensity, you lose everything."
Josef Koudelka

Gelatin silver print
Museum of Modern Art,
New York, USA

Girls Dancing at a Festival (1964)
Constantine Manos

Nomad Wedding in the Hindu Kush (1969)
Eve Arnold

Williamsburg, Brooklyn (2005)
William Meyers

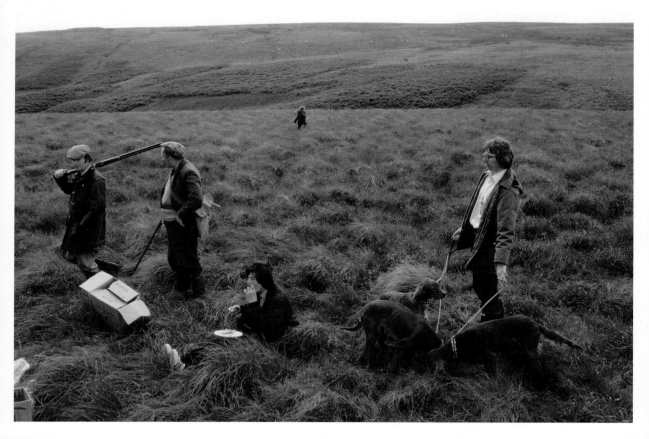

County Down, Ireland 1978
Marc Riboud

This photograph is a tightly controlled image of a moment of pause. The hunters are divided by social class, but in this break in activity the roles of the men are less defined, as all join in a common cause. The leashed dogs, waiting for the shoot to resume, are central to the image, providing a focal point of movement in this otherwise static photograph. *County Down, Ireland* is a study in anticipation, and, like many photojournalists of the 1970s, by choosing to photograph this moment of calm, Riboud tells us far more about the situation than an "action" photograph could explain.

Magnum photographer Marc Riboud is well known for his photojournalistic work, made throughout the world. In this photograph, taken in Ireland in the late 1970s, Riboud photographs his subjects in close foreground, with an expansive background of green hillside. This tightens the image and places the hunters in a specific location. Riboud's control of tone and color is impressive; taken on an overcast day, the image is imbued with soft, dull light that unifies the color, until the men and hillside seem merged into one. Although Riboud has photographed a group, all the figures are separate from one another, although bound together by a common activity. They are engrossed in their surroundings, oblivious to the solitary figure who walks away across the hillside.

Taking pictures is savoring life intensely, every hundredth of a second."
Marc Riboud

Irish Museum of Modern Art, Dublin, Ireland

Sunday on the Banks of the Marne (1938)
Henri Cartier-Bresson

Glyndebourne (1967)
Tony Ray-Jones

Provence (1976)
Martine Franck

Single Stone, Ring of Brogar, Orkney 1979
Fay Godwin

In this striking photograph, Godwin chose to feature only one of the stones from this Neolithic monument, rather than attempt to show the whole circle. By doing this, she was able to concentrate on texture and form, and the detail that she presents becomes symbolic of the whole. Godwin makes the stone the absolute center of the photograph, dwarfing the landscape that surrounds it. However, she makes no attempt to monumentalize it: it is viewed with interest rather than with awe. The light is sharp, which illuminates the detail of the stone; set against the cloudy sky, it has an ominous presence.

Fay Godwin's series of photographs about the British countryside was much acclaimed and became a catalyst for a revived interest in British landscape photography. *Single Stone, Ring of Brogar, Orkney* is typical of her approach to photography. She avoided the picturesque views that had dominated British landscape photography in the 1950s and 1960s, and instead presented rural Britain as a harsh and melancholy place. In this photograph, the stone appears as a giant, dominating the predominantly low-lying, treeless Orkney landscape. Godwin was a meticulous technician and endured considerable physical hardship to make this extensive series.

. . . [Godwin] catches the spirits of places that have been worn and weathered, deserted and abandoned, and yet still speak to us."
Margaret Drabble

Gelatin silver print
National Media Museum,
Bradford, UK

Canyon de Chelly (1941)
Ansel Adams National Archives and Records Administration, Washington, D.C., USA

Trees in Snow, near Saint-Moritz, Switzerland (1947)
Alfred Eisenstaedt

Two Barns and Shadow (1955)
Minor White

Haus Nr. 9 I 1989
Thomas Ruff

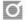

Haus Nr. 9 I is about the massiveness of architectural form combined with the small detailing of everyday life. Ruff made his series of photographs on dull days, when the quality of the daylight and the grayness of the sky would equate to the soft, faded colors of the buildings. Haus Nr. 9 I is almost a ruin, monument to the cheap, mass-produced modernism that dominated postwar Europe. The image is about the everyday and the unspectacular, and it expresses photography's ability to render both sublime.

Thomas Ruff's series of photographs of houses was made in Germany at the time of the collapse of communism in the late 1980s, and the body of work, in all its plainness and objectivity, mirrors a Europe on the brink of fundamental change. Haus Nr. 9 I is an apartment block set in a scarred landscape of grass, dotted with rubbish. The inhabitants of the block are barely present in Ruff's photograph, but the intimate signs of their existence—bedclothes hung over a peeling balcony, paper stuck onto a window, forms half-seen through window glass—are carefully described in the image and are central to its success.

You cannot explain the whole world in one photograph. Photography pretends. You can see everything that's in front of the camera, but there's always something beside it."

Thomas Ruff

Chromogenic print
Courtesy David Zwirner,
New York, USA

Close No. 75 High Street (1868)
Thomas Annan
Museum of Modern Art,
New York, USA

From the Shelton Westward—New York (1936)
Alfred Stieglitz
Philadelphia Museum of Art, USA

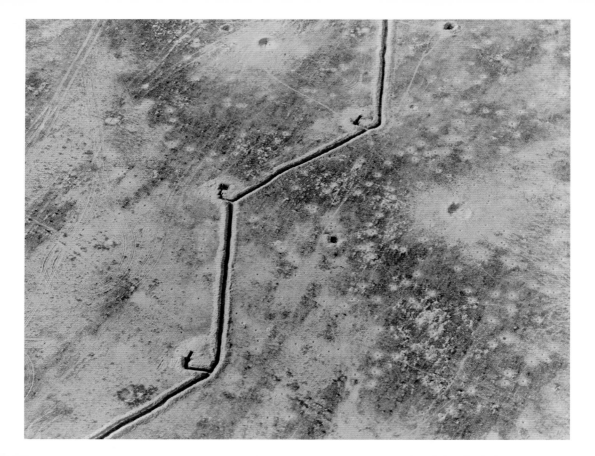

From the series *Fait* 1991
Sophie Ristelhueber

In this photograph from the series (detail, left), an arrangement of trenches cuts through the landscape, linking three groups of dug-outs. These scars on the desert, seen from far above, are at once a wound and a tracery; almost diagrammatic, they fix focus and invite comment. *Fait* is one of the most remarkable photographic works to emerge out of the modern war zone; although it contains no human subjects, it has become a monumental narrative of contemporary conflict. It is about the marks that men make on the landscape, and the traces they leave behind.

Sophie Ristelhueber made the series *Fait* in Kuwait six months after the end of the Gulf War. She had seen photographs of bomb craters in the desert and became interested in the scars inflicted on the landscape by battle and abandoned armaments. Taken from the air, this photograph becomes a near-abstract study of form, color, and texture. Yet it remains grounded in the landscape, and in recent history, never so abstracted that the sense of location and event is lost. By using aerial photography, more usually associated with survey and science than with art photography, Ristelhueber sets up interesting contradictions.

[Fait is] not about information and it's not about war. It's a work about scars. . . . I was not doing something fictional; I was making a fiction."

Sophie Ristelhueber

Chromogenic print
Photographer's collection

County Cork, Ireland (1967)
Richard Long
Metropolitan Museum of Art,
New York, USA

Dandelion Flowers Pinned With Thorns to Rosebay Willowherb Stalks (1985)
Andy Goldsworthy

The Eastern Part of the Brooks Range (2009)
Sebastião Salgado

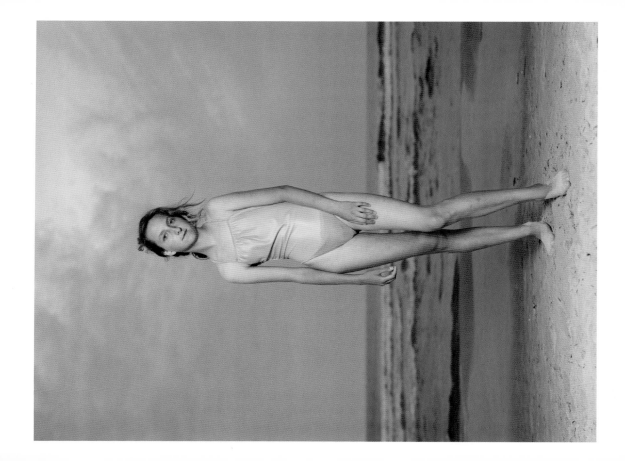

Kolobrzeg, Poland 1992
Rineke Dijkstra

Location is extremely important to Dijkstra, as shown very clearly in this photograph from the series of portraits that she made on European beaches in the early 1990s. The image represents a moment in history, time arrested, youth seen with a clear and thoughtful eye. Dijkstra's subject is not self-conscious, but she is clearly posing for the camera. Throughout the series, the photographer combines the directness of Walker Evans and Diane Arbus with a very modern sensibility and awareness of contemporary image making.

Dutch photographer Rineke Dijkstra uses a 4 x 5 camera to make portraits. Her series of beach portraits from the early 1970s is simple, direct, and memorable. This photograph, taken on a beach in Kolobrzeg, Poland, succeeds not only because of the photographer's ability to connect with the subject, but also through the precise calibration of subject and background. The young girl twists her body to one side, emphasizing both flow and form. The waves in the background are also tightly formed, as are the clusters of clouds in the sky above. Dijkstra's use of color is equally important: pale flesh tones, sand, and a shiny lime-green swimsuit standing out sharply against the blue background.

> It's important for me to know the location is right before I approach a subject.
> Then, I'll find the subject within that location and work from what the subject does."
> **Rineke Dijkstra**

Chromogenic print
Metropolitan Museum of Art,
New York, USA

Madras (1971)
Edouard Boubat

Sulu Sea, Philippines (1985)
Steve McCurry

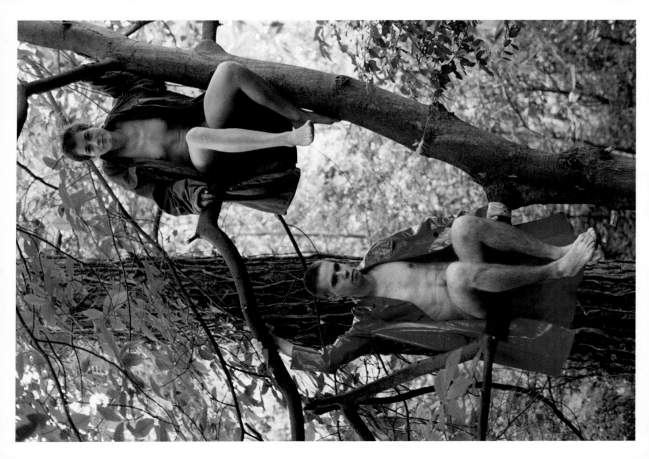

Lutz and Alex Sitting in the Trees

1992 Wolfgang Tillmans

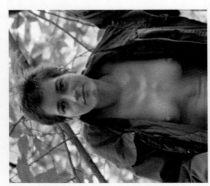

This is a striking portrait of friends and collaborators. Despite its seeming informality, *Lutz and Alex Sitting in the Trees* is a carefully controlled and composed photograph. The clothes are clearly styled, and the two models express an intense modernity. The photograph is honest and uncompromising about the human body: nothing has been removed from this image to make it more seductive and smooth. There is hair on the body, puckered skin, and protruding bones; there is discomfort and unpredictability.

This image is one of Wolfgang Tillman's best-known photographs, and it shows the inventiveness and boldness that characterizes his work. Perched in the trees and half-clothed in waterproofs, Alex and Lutz are like two solemn creatures discovered by a passing naturalist. They pose with confidence, young and graceful, although not with conventional glamour. Made at a time when fashion photography was moving toward an antiglamour snapshot aesthetic, the image became an important symbol of change. It is a serious comedy, a play on photographic aesthetics, and a challenge to ideas about beauty.

> *Art that I like speaks from its time about its time, but it also possesses something enduring beyond its novelty."*
>
> **Wolfgang Tillmans**

Chromogenic print
Victoria & Albert Museum,
London, UK

Skinheads, Brighton (1980)
Derek Ridgers

Park Portraits series (c.2006)
Rineke Dijkstra

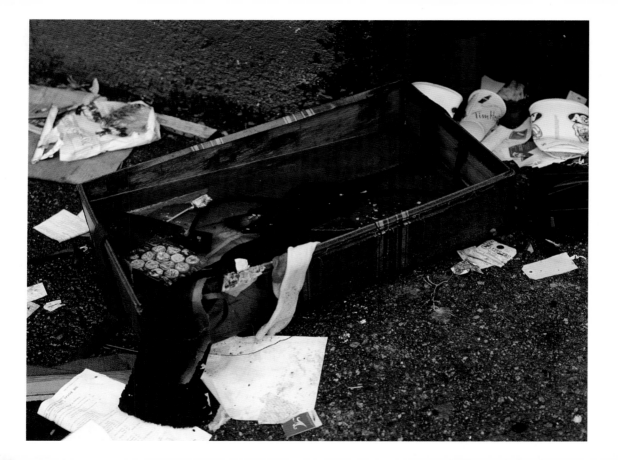

Rainfilled Suitcase 2001
Jeff Wall

One of the most innovative artists using photography in the 1990s, Wall constructs a classic scene of urban abandonment in this photograph. It is a mysterious tableau: the ruined case contains only a scattering of discarded objects. Everything in the photograph is broken, sodden in the rain, torn, or crushed. For Wall, the relationship with photography is a crucial one, and in this image he skillfully uses the medium to ground the invented scenario in an authored reality, while at the same time using the choreography of cinematography to create a narrative of mystery and loss.

Rainfilled Suitcase is a complex photograph of an everyday situation. Focusing on a minor event, a suitcase abandoned outside on a city street, the photograph is open to multiple interpretations: from the literal, as a banal streetscape, to the profound, a legend of city life and the street as a place of stories. Discarded objects became favored subject matter for photographers in the 1990s, when ideas of dislocation and damage became an important theme across Western culture. Jeff Wall's photographic works imply a satedness, a theater of despair that was entirely in tune with its times.

The everyday, or the commonplace, is the most basic and the richest artistic category. Although it seems familiar, it is always surprising and new."
Jeff Wall

Silver dye bleach transparency in light box
Photographer's collection

Untitled No. 175 (1975)
Cindy Sherman

Water Babies (1976)
M. Richard Kirstel

Public Leisure Party (2010)
Peter Funch

Ansel Adams

b. 1902 San Francisco,
California, USA
d. 1984 Monterey, California, USA

Ansel Adams was one of
the United States' foremost
landscape photographers.
He cofounded Group f/64
in 1932 with photographers
including Edward Weston
and Imogen Cunningham,
opened his own gallery in
San Francisco a year later,
and was instrumental in
establishing the photography
department at the Museum
of Modern Art, New York. In
1941, Adams developed the
zone system, a technique
to control exposure and
development on negatives
and paper.

» *Sand Dunes, Sunrise* p.61

Nobuyoshi Araki

b. 1940 Tokyo, Japan

Nobuyoshi Araki is one
of Japan's most prolific
photographers and has
published numerous
books, many of which deal
with the erotic. He studied
photography and filmmaking
at Chiba University, Tokyo,
from 1959 to 1963, and was
employed as a photographer
for the advertising agency
Dentsu Inc. between 1963
and 1971. He founded the
Photo Workshop in 1974, has
published in magazines, and
exhibited his photographs
internationally over the last
three decades.

» From the series *The Banquet*
p.103

Eve Arnold

b. 1912 Philadelphia,
Pennsylvania, USA
d. 2012 London, UK

Eve Arnold studied
photography at New York's
New School for Social
Research and joined
Magnum Photos in 1951. Best
known as a portraitist, her
images of Marilyn Monroe
are particularly memorable.
Arnold also traveled
extensively and held her first
solo exhibition in China in
1980. She has published a
number of monographs,
including *The Unretouched
Woman* in 1976 and *In
America* in 1986, and made
a notable series of portraits
of the wives of US presidents.

» *Margot Fonteyn and Rudolf
Nureyev* p.173

Miriam Bäckström

b. 1967 Stockholm, Sweden

Miriam Bäckström lives and
works in Stockholm. She has
made a number of photo
series that examine ideas of
the domestic, the enacted,
and the displayed. Her
series *Estate of a Deceased
Person* (1992–96), *Set
Constructions* (1995–2002),
and *Museums, Collections,
and Reconstructions*
(1999–2004) all examine
the representation of the
real, the remembered,
and the constructed. She
represented Sweden at the
Nordic Pavilion at the Venice
Biennale in 2005.

» From the series *Set
Constructions S014* p.121

Roger Ballen

b. 1950 New York, New York, USA

Roger Ballen has lived in Johannesburg, South Africa, since the 1970s. His photography encompasses notions of both documentary and constructed realities, as seen in a series of photographs, begun in 1982, featuring the homes and lives of people in marginal white communities in South Africa. His work has been exhibited extensively internationally, and he has published several monographs including *Fact or Fiction* (2003) and *Shadow Chamber* (2005).

» *Dresie and Casie, Twins, Western Transvaal* **p.87**

Tina Barney

b. 1945 New York, New York, USA

Tina Barney lives and works in Rhode Island. She was interested in photography as a child but did not begin to make photographs until the mid-1970s. Barney is now known for her large-scale color portraits of family and friends, many of whom are among New York and New England's social elite. Monographs include *Friends and Relations* (1991), and her work has featured in many major exhibitions, including "Who's Looking at the Family?" at the Barbican Art Gallery, London, in 1994.

» *The Landscape* **p.85**

Cecil Beaton

b. 1904 Hampstead, London, UK
d. 1980 Broad Chalke, Wiltshire, UK

Cecil Beaton was a self-taught photographer who became one of the most celebrated portraitists of his time. His photographs of socialites, Hollywood stars, and the European avant-garde captured the spirit of their times. In 1939, Beaton photographed Queen Elizabeth, the Queen Mother, thus beginning a career as a royal photographer. He published many books of photographs and was a prolific diarist as well as a celebrated costume designer for film and theater.

» *Gertrude Stein and Alice B. Toklas* **p.73**

Ian Berry

b. 1934 Preston, Lancashire, UK

Ian Berry is a British photojournalist who photographed the Sharpeville Massacre in 1960, while working for the magazine *Drum*. He joined Magnum Photos in 1962—invited by Henri Cartier-Bresson—and worked for many years for a range of publications, most notably the *Observer*. He is now best known for a series of documentary photographs made in the United Kingdom in the late 1960s and 1970s and published in the monograph *The English* in 1978.

» *Chelsea Flower Show* **p.159**

Richard Billingham

b. 1970 Birmingham, UK

Richard Billingham studied art at the Bourneville College of Art and the University of Sunderland, graduating in 1994. His work first came to critical attention in the exhibition "Who's Looking at the Family?" held at the Barbican Art Gallery in London in 1994. Billingham is best known for his series of photographs of his family taken at their home; they were published as a book titled *Ray's a Laugh* in 1996. He was awarded the Citibank Photography Prize in 1997.

» From the series *Ray's a Laugh* p.175

Margaret Bourke-White

b. 1904 New York, New York, USA
d. 1971 Stamford, Connecticut, USA

Margaret Bourke-White was commissioned by Otis Steel Company in 1927 to take promotional photographs of its factories in Cleveland, Ohio, and went on to become a major contributor to *Fortune* and *Life* magazines. She worked in partnership with Erskine Caldwell on "You Have Seen Their Faces" (1937), which tells the story of the American South in the Great Depression. She photographed the liberation of Europe for *Life* magazine and traveled extensively as a photojournalist.

» The Living Dead of Buchenwald **p.129**

Bill Brandt

b. 1904 Hamburg, Germany
d. 1983 London, UK

Bill Brandt emigrated from France to Britain in 1934. He worked as a photodocumentarist for magazines including *Lilliput* and *Picture Post*. His books *The English at Home* (1936), *A Night in London* (1938), and *Perspective of Nudes* (1961) are now regarded as some of photography's most important publications. His retrospective at the Museum of Modern Art in New York and London's Hayward Gallery in 1969 influenced new generations of documentary photographers.

» Tic-Tac Men at Ascot Races **p.25**

Brassaï

b. 1899 Brasov, Romania
d. 1984 Beaulieu-sur-Mer, Alpes-Maritimes, France

Born in what was then Brassó, Hungary, Gyula Halász worked as a photojournalist in Berlin before moving to France in 1924, where he adopted the name "Brassaï," meaning "from Brassó." He is best known for his monograph *Paris de Nuit* (*Paris By Night*, 1933), which portrays the city's demimonde. Dubbed "the eye of Paris" by his friend, US writer Henry Miller, Brassaï's work was dramatic and revelatory, capturing the essence of interwar European culture.

» A Monastic Brothel **p.151**

Larry Burrows

b.1926 London, UK
d.1971 Laos

Larry Burrows was born in London and worked at *Life* magazine's London office as a photographic printer, before becoming a *Life* photographer in 1945. Best known for his photographs of the Vietnam War, which he began in 1962 and continued until his death, he also covered many international war zones. Burrows was killed during a missile attack while photographing near the Laos border in 1971. A retrospective book, *Larry Burrows: Vietnam*, was published in 2002.

» *Mutter Ridge, Nui Cay Tri, South Vietnam* **p.135**

Andrew Bush

b.1956 St. Louis, Missouri, USA

Andrew Bush published *Bonnettstown: A House in Ireland* in 1989. It features his series of images of an Irish country house that he visited in the early 1980s when he was hitchhiking in Europe, after completing a master's degree in photography at Yale University. Bush has authored many series of photographs, including *Homeless Sites* (2007), *Elysian Park* (2007), and *Prop Portraits* (1998–2000). His books include Drive (2008), which contains images of people driving in Los Angeles.

» "A House in Ireland," from the series *Bonnettstown* **p.113**

Robert Capa

b.1913 Budapest, Hungary
d.1954 Thai-Binh, Indochina

Hungarian-born Endre Friedmann, later known as Robert Capa, studied political science at Deutsche Hochschule für Politik in Berlin, Germany. After emigrating from Nazi Germany in 1933, he moved to France, where he worked as a freelance photographer, covering many international conflicts, including the Spanish Civil War, World War II, and the First Indochina War. In 1947, Capa cofounded the Magnum Photos agency. He died on assignment in Indochina.

» *Looking at German Luftwaffe Pilots Flying Over the Gran Via* **p.125**

Henri Cartier-Bresson

b.1908 Chanteloup-en-Brie,
 France
d.2004 Montjustin, France

Henri Cartier-Bresson was born in Chanteloupe, France. He acquired his first Leica camera in 1932 and developed a style of street photography that combined instantaneity with meticulous structure. He was a cofounder of Magnum Photos agency and traveled extensively and internationally as a magazine photojournalist. His monograph *Images à la sauvette* (*The Decisive Moment*, 1952) established him as one of Europe's most significant photographers.

» *Gestapo Informer, Dessau, Germany* **p.75**

Krass Clement

b. 1946 Copenhagen, Denmark

Danish photographer Krass Clement studied cinematography at the National Film School of Denmark in Copenhagen but decided to pursue a career as a documentary photographer. His monographs include *Skygger af øjeblikke* (*Shadows of the Moment*, 1978) and *Drum: Et sted i Irland* (*Drum: A Place in Ireland*, 1996). The latter focuses on life in a small community in County Monaghan, Ireland. His work has been widely exhibited, particularly in the Nordic countries.

» From the series *Drum* **p.105**

Bruce Davidson

b. 1933 Oak Park, Illinois, USA

After graduating from Yale University, Bruce Davidson served in the US army and was posted to Paris, where he met Henri Cartier-Bresson. When Davidson left the military in 1957, he worked as a freelance photographer, joining Magnum Photos a year later. His monograph *Brooklyn Gang* (1959) established his reputation as a documentary photographer and his *East 100th Street* (1970) is regarded as one of documentary photography's most influential publications.

» From the series *Brooklyn Gang* **p.133**

Rineke Dijkstra

b. 1959 Sittard, Limburg, Netherlands

Rineke Dijkstra studied art at Amsterdam's Gerrit Rietveld Academie. She worked as a commercial portrait photographer until the early 1990s, from which point she began to produce series of austere and highly detailed portrait photographs in color, such as *Beaches* (1992–96). Her subjects included mothers, matadors, clubbers, and members of the French Foreign Legion. Her work has been exhibited at the Guggenheim in New York, Tate Modern in London, and at the Venice Biennale.

» *Kolobrzeg, Poland* **p.191**

William Eggleston

b. 1939 Memphis, Tennessee, USA

William Eggleston began working with photography in the early 1960s. His work attracted critical attention as he produced enigmatic images of the everyday—including shopping malls, vending machines, and signage. His solo show "Color Photographs" was shown at New York's Museum of Modern Art in 1976, and his monograph *William Eggleston's Guide* appeared in the same year. His work influenced generations of later photographers, including Martin Parr.

» *Greenwood, Mississippi* **p.95**

Walker Evans

b. 1903 St. Louis, Missouri, USA
d. 1975 New Haven,
 Connecticut, USA

Walker Evans's documentary photographs of everyday life, most notably the work he made in the American Dustbowl in the 1930s, established him as a major photographic force. His solo show, "Walker Evans: American Photographs," at New York's Museum of Modern Art in 1938 signaled a new kind of documentary photography. He collaborated with James Agee on the book *Let Us Now Praise Famous Men*, showing rural poverty in the United States, which was published in 1941.

» *Interior of Coal Miner's Home, West Virginia* **p.109**

Fay Godwin

b. 1931 Berlin, Germany
d. 2005 Hastings, East Sussex, UK

The daughter of a British diplomat and a US artist, Fay Godwin settled in London in 1958. She collaborated with poet Ted Hughes to produce *Remains of Elmet* (1979), a collection of photographs to accompany Hughes's poems. A celebrated landscape photographer, she was also a staunch defender of walkers' rights and used her photography to examine and highlight environmental issues. She published many monographs, including *The Oldest Road* (1975) and *Our Forbidden Land* (1990).

» *Single Stone, Ring of Brogar, Orkney* **p.185**

Jim Goldberg

b. 1953 New Haven,
 Connecticut, USA

Jim Goldberg studied photography at San Francisco Art Institute, graduating in 1979. His work first attracted critical attention in 1984 when he exhibited at the Museum of Modern Art, New York, alongside Joel Sternfeld and Robert Adams in the show "Three Americans." Goldberg describes himself as a "documentary storyteller" and is best known for his innovative use of text and images. His published works include *Rich and Poor* (1985), *Raised by Wolves* (1995), and *Open See* (2009).

» From the series *Rich and Poor* **p.83**

Nan Goldin

b. 1953 Washington, D.C., USA

Nancy "Nan" Goldin had her first solo show in Boston in 1973, based on her work documenting the city's gay and transsexual communities. Having moved to New York in 1978, she began a series of portraits of her friends, some of which appeared in *The Ballad of Sexual Dependency* (1979–86). Many photographers in the 1980s and 1990s adopted Goldin's informal, intimate style, and her work has been shown internationally over the last three decades.

» *Nan and Brian in Bed* **p.43**

Paul Graham

b. 1956 Stafford, Staffordshire, UK

Paul Graham was one of the new British colorists of the 1980s. His monograph *A1: the Great North Road* appeared in 1981, and from 1984 to 1985 he worked on the series *Beyond Caring*, a clandestine documentation of the waiting rooms in British Unemployment Benefit offices during a time of high unemployment. Graham has subsequently produced many significant photo series, including *Troubled Land* (1984–86), which explored the landscape of Northern Ireland.

» From the series *Beyond Caring* **p.97**

Ernst Haas

b. 1921 Vienna, Austria
d. 1986 New York, New York, USA

Ernst Haas became a staff photographer for the magazine *Heute* (Today) in 1947. His work came to the attention of Robert Capa, who invited him to join the Magnum Photos agency. Haas moved to New York in 1953, where he worked for *Life* magazine. His solo show in 1962 was held at New York's Museum of Modern Art. Haas published a number of books, including *In Germany* (1976) and *Himalayan Pilgrimage* (1978). He received the Hasselblad Award in 1986.

» *Homecoming Prisoners, Vienna* **p.131**

Jacqueline Hassink

b. 1966 Enschede, Overijssel, Netherlands

New York–based conceptual artist Jacqueline Hassink trained as a sculptor before moving into photography in 1993. She is known for her examinations of economic power, globalization, corporate identity, and the boundaries between the private and public domain. Her first project, *The Table of Power* (1993–95), featured images of the boardrooms of Europe's forty largest multinational corporations. Her published works include *The Mindscapes* (2003) and *The Power Book* (2007).

» From the series *The Table of Power* **p.29**

Florence Henri

b. 1893 New York, New York, USA
d. 1982 Compiègne, Oise, France

Florence Henri was born in New York and became a member of the New Vision movement. She studied music and painting and attended the Bauhaus in Dessau in 1927, studying under artists Josef Albers and László Moholy-Nagy. Henri made many photographic experiments in the late 1920s and 1930s and took part in the exhibition "Film und Foto" in Stuttgart. In 1929 she moved to Paris and established a studio, producing work for magazines including *Vogue*.

» *Autoportrait* **p.53**

Lewis Hine

b. 1874 Oshkosh, Wisconsin, USA
d. 1940 Dobbs Ferry,
 New York, USA

Lewis Wickes Hine began photographing for the National Child Labor Committee in 1908, and his photographs appeared on posters and in journals that advocated the reform of child labor laws. He photographed in Europe for the American Red Cross during World War I and was an influential teacher at the Ethical Culture School. Hine's work was shown as a solo show at the Yonkers Museum in 1931, and his celebrated *Men at Work* monograph was published in 1932.

» *Textile Mill, USA* p.19

Horst P. Horst

b. 1906 Weissenfels, Germany
d. 1999 Palm Beach Gardens,
 Florida, USA

Horst Paul Albert Bohrmann (later known as Horst P. Horst) studied furniture design and carpentry at the Hamburg Kunstgewerbeschule (School of Arts and Crafts). He moved to Paris in 1930, where he worked with George Hoyningen-Huene, and was commissioned by *Vogue*. He moved to the United States at the start of World War II and joined the US army as a photographer. Postwar, he worked for US *Vogue* and published monographs including *Photographs of a Decade* (1944).

» *Goya Fashion* p.153

Eric Hosking

b. 1909 London, UK
d. 1991 London, UK

Eric Hosking was an eminent British photographer and editor, who pioneered techniques in bird photography, including electronic flash and automatic shutter release. He authored many books about birds, including his autobiography, *An Eye for a Bird* in 1970. Hosking was awarded a Gold Medal by the Royal Society for the Protection of Birds in 1974 and received an Order of the British Empire in 1977 for his natural history photography and work in conservation.

» *Barn Owl* p.169

George Hoyningen-Huene

b. 1900 St. Petersburg, Russia
d. 1968 Los Angeles, CA, USA

G
H

During the Russian Revolution, George Hoyningen-Huene fled to London and then Paris. There he collaborated with Man Ray, supplying sitters, props, and backgrounds to produce a portfolio of "the most beautiful women in Paris." Hoyningen-Huene joined French *Vogue* in 1926, where he produced innovative studio pictures, often inspired by Greek sculpture and classical forms. From 1935 he was based in New York, before moving to Hollywood and specializing in celebrity portraits.

» *Divers* p.57

Philip Jones Griffiths

b. 1936 Rhuddlan,
 Denbighshire, UK
d. 2008 London, UK

Philip Jones Griffiths trained as a pharmacist and began to contribute photographs to the *Manchester Guardian*, becoming a staff photographer in 1961 for the *Observer*. He worked in Vietnam from 1966, documenting the war for the Magnum Photos agency, and published the seminal book *Vietnam Inc.* in 1971. He covered the Yom Kippur War in 1973 and then worked in Cambodia until 1975. He was president of Magnum Photos from 1980 to 1985.

» *Soldiers With a Group of Captured Subjects* **p.137**

Sune Jonsson

b. 1930 Nyåker, Sweden
d. 2009 Nyåker, Sweden

Olov Sune Jonsson studied English, ethnology, and literature at Stockholm and Uppsala universities. His first photo book, *Byn med det blå huset* (*The Village With the Blue House*, 1959), depicts people in Djupsjönäs and his hometown of Nyåker. From 1961 to 1995, Jonsson worked as a photographer for the Museum of Västerbotten in Umeå, documenting cultural life in rural areas by taking photographs of farmers, landscapes, and religious gatherings, mainly in the province of Västerbotten.

» From the series *Västerbotten* **p.111**

Colby Katz

b. 1975 Washington, D.C., USA

Portraitist and documentary photographer Colby Katz was raised in Florida and graduated from New York University in 1998 with a bachelor's degree in fine art. Her work focuses on US subcultures, from sideshow performers and backyard fighters to paparazzi and nudists. She is known in particular for her empathetic series of images of small-town beauty pageants, which convey the ritual of these often-controversial events and give a voice to the young contestants and their parents.

» *Rayne-Lin, Little Miss Firecracker, L.A.* **p.69**

André Kertész

b. 1894 Budapest, Hungary
d. 1985 New York, New York, USA

André Kertész abandoned a career as a stockbroker to take up photography. He bought his first camera in 1912 and began to take images of local country people and gypsies. He served in the Austro-Hungarian army during World War I and took photographs of life in the trenches. Kertész moved to Paris in 1925 and contributed to magazines including *Vu*. In 1936 he immigrated to the United States, where he worked as a magazine photographer for *Harpers Bazaar* and *Life*.

» *Circus, Budapest* **p.35**

Josef Koudelka

b. 1938 Boskovice, Moravia,
 Czech Republic

Josef Koudelka gave up a career as an aeronautical engineer to become a photographer in 1967. He began a series of photographs of gypsies in Slovakia and Romania and photographed the Soviet invasion of Czechoslovakia. He joined Magnum Photos in 1971, and his monograph *Gypsies* was published in 1975, followed by *Exiles* in 1988. His retrospective was held in 2002 at the Rencontres Internationales de la Photographie in Arles, France.

» "Straznice," from the series *Gypsies* **p.181**

Dorothea Lange

b. 1895 Hoboken, New Jersey, USA
d. 1965 San Francisco,
 California, USA

Dorothea Nutzhorn adopted her mother's maiden name, "Lange," when she was twelve years old. She studied photography under Clarence H. White at Columbia University then moved to San Francisco, where she opened a portrait studio. During the Depression, Lange was employed by the Resettlement Administration to document the lives of rural people. After World War II she taught the fine art photography course at the California School of Fine Arts with Ansel Adams and Imogen Cunningham.

» *Migrant Family* **p.37**

Grace Lau

b. 1939 London, UK

Grace Lau studied at Newport College of Art and the University of Westminster London College of Communication. While writing *Picturing the Chinese* about Western perceptions of the Chinese during the nineteenth century, she re-created a Chinese portrait studio in Hastings. This resulted in an archive of modern twenty-first-century "types," an echo of early Western photographs of the Chinese as seen in her book. The work was shown at Tate Britain in 2007 and toured the United Kingdom.

» From the series *21st Century Types* **p.163**

Susan Lipper

b. 1953 New York, New York, USA

Susan Lipper studied photography at Yale School of Art and graduated in 1983. Her series of photographs of the small rural community of Grapevine Hollow, West Virginia, was made between 1988 and 1992. It was published as the monograph *Grapevine* (1994). Lipper's work has been widely exhibited at Tate Britain, the Barbican Art Gallery, and the Victoria & Albert Museum in London and Yossi Milo Gallery in New York. Her monograph *Trip* was published in 2000.

» From the series *Grapevine* **p.117**

J
K
L

Esko Männikkö

b. 1959 Pudasjärvi, Oulu,
 Northern Ostrobothnia,
 Finland

Esko Männikkö was born and continues to work in Finland, where he has documented the lives of rural people living in isolated communities. His photographs, presented in vintage frames, first attracted attention outside the Nordic countries in the late 1990s, and his monograph *The Female Pike* was published in 2000. Männikkö has exhibited and published internationally over two decades. His work was included in the Liverpool Biennale in 2004.

» *Kuivaniemi, Finland* **p.119**

Man Ray

b. 1890 South Philadelphia,
 Pennsylvania, USA
d. 1976 Paris, France

Man Ray was born Emmanuel Radnitzky in Philadelphia. An early member of Dada groupings in New York, he moved to Paris in the early 1920s and became part of a European avant-garde. As a filmmaker and experimental photographer, Man Ray was closely associated with the Paris surrealists. His development of "rayograms" and solarization as well as a series of portraits of European bohemia were important markers in the development of interwar experimentalism.

» *A Solarized Portrait of Lee Miller* **p.55**

Roger Mayne

b.1929 Cambridge,
 Cambridgeshire, UK

Roger Mayne studied chemistry at Oxford University, where he became interested in photography. He worked as a freelance photographer in London in the 1950s, contributing to a number of magazines including *Picture Post*. Mayne's photo series, made in and around Southam Street in London's Notting Dale between 1956 and 1961, brought a new intimate style to British photojournalism. His retrospective was shown at the Victoria & Albert Museum in London in 1986.

» From the series *Southam Street* **p.171**

Susan Meiselas

b.1948 Baltimore, Maryland, USA

After studying at Harvard University, Susan Meiselas worked in photographic education for much of the 1970s, before becoming a photodocumentarist and reporter. Her monograph *Carnival Strippers* was published in 1976. She joined Magnum Photos agency in 1976 and documented human rights issues in Latin America in the late 1970s and 1980s, covering the Nicaraguan Revolution and El Mozote massacre in El Salvador. Her monograph *Nicaragua* was published in 1981.

» *Youths Practice Throwing Contact Bombs* **p.141**

Boris Mikhailov

b. 1938 Kharkov, Ukraine

Boris Mikhailov was born in Kharkov in the Ukraine. His portraits of marginal communities in his home region brought him to international attention in the 1990s. Mikhailov's series *At Dusk* (1993) and *Case History* (1997–98) examined the plight of the dispossessed of the former Soviet Union. He has exhibited in venues such as the Saatchi Gallery, London, and the Sprengel Museum, Hannover. A retrospective publication, *Boris Mikhailov: A Retrospective*, was published in 2003.

» From the series *Case History* **p.89**

Lee Miller

b. 1907 Poughkeepsie,
New York, USA
d. 1977 Chiddingly, Sussex, UK

Elizabeth "Lee" Miller, Lady Penrose became a fashion model in New York before moving to Paris in 1929, where she worked as a photographic assistant to Man Ray. She returned to New York in 1932 and set up her own photographic studio. Miller worked as a photojournalist for *Vogue* magazine during World War II, photographing the liberation of the concentration camps and documenting the aftermath of war. Her publications include *Wrens in Camera* (1945).

» *Dead SS Guard Floating in Canal, Dachau* **p.127**

Barbara Morgan

b. 1900 Buffalo, Kansas, USA
d. 1992 Tarrytown, New York, USA

Born Barbara Brooks Johnson, Barbara Morgan grew up in California. She studied painting at the University of California in Los Angeles. Morgan moved to New York in the mid-1930s and began a collaborative project with dancer Martha Graham, photographing her and her company. A collection of the photographs was published in 1941 in the book *Martha Graham: Sixteen Dances in Photos*. Morgan cofounded the influential photographic magazine *Aperture* in 1952.

» *Martha Graham, Frontier* **p.167**

Nicholas Nixon

b. 1947 Detroit, Michigan, USA

Nicholas Nixon is a landscape photographer whose work was included in the groundbreaking show "New Topographics: Photographs of a Man-altered Landscape," held in 1975 at the International Museum of Photography. He has been photographing the Brown sisters since 1975, making an ongoing series of portraits of his wife and her three sisters taken annually in the same pose. He has exhibited widely, including at the Museum of Modern Art in New York.

» *The Brown Sisters, New Canaan* **p.77**

M
N

Simon Norfolk

b. 1963 Lagos, Nigeria

Simon Norfolk studied philosophy and sociology at Oxford and Bristol universities. He worked as a photojournalist specializing in antiracist activities and fascist groups, before beginning to work with landscape in the mid-1990s. Norfolk's *For Most of It I Have No Words: Genocide, Landscape, Memory* (1998) signaled a new way of using photojournalism, and he has continued to work with large-scale color prints in projects including *Afghanistan: chronotopia* (2002).

» *Former Teahouse in a Park, Kabul* **p.143**

Martin Parr

b. 1952 Epsom, Surrey, UK

Martin Parr studied photography at Manchester Polytechnic. He was a leading member of a new group of independent photographers that emerged in the United Kingdom in the early 1970s. His well-known publication *The Last Resort: Photographs of New Brighton* (1986) documented a fading seaside resort in the north of England. He has authored innumerable books of photographs and is also a curator, editor, and a member of Magnum Photos agency.

» From the series *The Last Resort* **p.99**

Gilles Peress

b. 1946 Neuilly-sur-Seine, Hauts-de-Seine, France

French photographer Gilles Peress is a member of Magnum Photos agency. In 1972 he traveled to Northern Ireland to begin what became a twenty-year project documenting "The Troubles." It was published in book form as *Power in the Blood: Photographs of the North of Ireland* (1994). Peress traveled extensively, and other important publications include *Telex: Iran-in the Name of the Revolution,* published in 1984, and *Farewell to Bosnia,* published in 1994.

» *One Minute Before British Paratrooper Fires* **p.139**

Anders Petersen

b. 1944 Solna, Stockholm, Sweden

Swedish photographer Anders Petersen studied at Christer Stromholm's Photographic School in Stockholm in the 1960s. His documentary photo series featuring the Hamburg demimonde was published as *Café Lehmitz* in 1978. Petersen's publications include *Grona Lun* (1973), *A Day at the Circus* (1976), and *Fängelse (Prison,* 1984), which documents life in a high-security prison. His retrospective exhibition was shown at the National Media Museum in Bradford in 2011.

» *Café Lehmitz* **p.41**

Mark Power

b.1959 Harpenden, Hertfordshire, UK

Mark Power graduated in fine art from Brighton Polytechnic in 1981. He began teaching in 1992 and was appointed professor of photography at the University of Brighton. He became a member of Magnum Photos agency in 2002. Power has published several monographs, including *The Shipping Forecast* (1996), *26 Different Endings* (2007), and *The Sound of Two Songs* (2010), which is a portrait of Poland between 2004 and 2008. He has exhibited widely around the world.

» "Gdansk," from the series *The Sound of Two Songs* **p.45**

Marc Riboud

b.1923 Lyon, France

Marc Riboud began his career as an engineer, after serving with the French Resistance and the Free French army during World War II. He became a freelance photojournalist based in Paris and joined the Magnum Photos agency in 1953. Three years later, Riboud was one of the first European photographers to visit China. His monographs include *The Three Banners of China* (1966), *The Face of North Vietnam* (1970), *Visions of China* (1981), and *In China* (1997).

» *County Down, Ireland* **p.183**

Derek Ridgers

b.1952 Chiswick, Middlesex, UK

Derek Ridgers trained as a graphic artist at Ealing School of Art and took up photography in the early 1970s. His work was published in magazines including *Face* and the *New Musical Express*. During the late 1970s and the 1980s, he made documentary portraits of the skinhead, fetish, punk, and New Romantic club and social scenes in Britain, and a selection of this work was published in *When We Were Young: Street and Club Portraits* (2006).

» *Helena, Sloane Square* **p.63**

Sophie Ristelhueber

b.1949 Paris, France

Sophie Ristelhueber is based in Paris and has made an extensive series of photographs portraying the impact of war on architecture and landscape, in locations including Bosnia, the West Bank, Beirut, Kuwait, and Iraq. Her publications include *Fait* (*Aftermath*, 1992), *W(est) B(ank)* (2005), and *Operations* (2009). A number of her works were presented in a major exhibition at the Jeu de Paume, France, in 2009, and she was awarded the Deutsche Börse Photography Prize in 2010.

» From the series *Fait* **p.189**

Thomas Ruff

b. 1958 Zell am Harmersbach,
 Baden-Württemberg,
 Germany

Thomas Ruff studied photography from 1977 to 1985 at the Kunstakademie Düsseldorf (Dusseldorf Art Academy). His series *Porträts* (*Portraits*, 1981) was critically acclaimed and widely exhibited. One of the first European artists to produce large-scale color exhibition prints, Ruff—along with his contemporaries Thomas Struth and Andreas Gursky—has become a major art photographer. His work has been exhibited internationally, including at the Venice Biennale.

» *Haus Nr. 9 I* **p.187**

Sebastião Salgado

b. 1944 Aimorês,
 Minas Gerais, Brazil

Sebastião Salgado studied economics at the University of São Paulo before becoming a professional photographer. After working with the Paris-based agencies Sygma and Gamma, he joined Magnum Photos in 1979 and now operates his own agency, Amazonas Images. His publications include *Workers* (1997), *Migrations* (2000), and *Afrika* (2007). With his wife, Leila, he is an active campaigner for environmental preservation, and together they founded the Instituto Terra in 1998.

» *Gold Mines of Serra Pelado, Brazil* **p.27**

August Sander

b. 1876 Herdorf, Rheinland-Pfalz,
 Germany
d. 1964 Cologne, Germany

After training as a photographer's assistant in the German army, August Sander became a studio portraitist. Fascinated by the "ordinary," Sander began to make a photographic typology—"People of the Twentieth Century"—a selection of which appeared in *Antlitz der Zeit: 60 Fotos Deutscher Menschen* (*Face of Our Time*, 1929). Acknowledged as one of the most significant photographers of the twentieth century, Sander has exhibited worldwide.

» *Bricklayer* **p.23**

Cindy Sherman

b. 1954 Glen Ridge,
 New Jersey, USA

Cindy Sherman studied painting and then photography at New York State University College at Buffalo. In 1977 she moved to New York and began the series *Untitled Film Stills* (1977–80). Sherman's ongoing work around disguise and masquerade remains a potent force in contemporary photography. She has exhibited at major venues, including the Museum of Modern Art, New York; the Whitney Museum, New York; Tate Modern, London; and the Centre Pompidou, Paris.

» *Untitled Film Still, No. 3* **p.39**

Margriet Smulders

b. 1955 Bussum, North Holland,
 Netherlands

Dutch photographer Margriet
Smulders studied art at the
Academy of Visual Arts in
Arnhem. She is best known
for her self-portraits and
photographs of her family.
Her constructed portraits of
domestic life were included
in the exhibition "Who's
Looking at the Family?" at the
Barbican Art Gallery, London,
in 1994, and since 1999, she
has worked on an ongoing
series of floral still life
photographs. A monograph,
Tulipomania, was published
in 2004, followed by *Bloody
Hell and Lucylures* in 2008.

» *Amor Omnia Vincit* **p.67**

Chris Steele-Perkins

b. 1947 Rangoon, Burma

Chris Steele-Perkins studied
psychology at Newcastle
University, becoming a
photojournalist in 1971. His
first book, *The Teds* (1979),
documented youth culture in
the United Kingdom. He
joined Magnum Photos in
1983 and produced *Survival
Programmes* (1981) with Paul
Trevor and Nicholas Battye,
which documented social
conditions in Britain. Steele-
Perkins has traveled widely,
visiting South Korea, El
Salvador, Afghanistan, and
Bangladesh to report on
poverty, slavery, and war.

» From the series *The Teds* **p.79**

Edward Steichen

b. 1879 Bivange, Luxembourg
d. 1973 Connecticut, USA

Originally a pictorialist,
Edward Steichen cofounded
the 291 gallery and the
magazine *Camera Work* with
Alfred Stieglitz. Active as an
aerial photographer in World
War I, he emerged as a
reforming modernist in
the 1920s and became a
distinguished commercial
and fashion photographer.
Steichen joined the Museum
of Modern Art, New York,
after World War II, heading
the photography department.
In 1955, he organized the
"Family of Man" exhibition,
which toured internationally.

» *The Flatiron* **p.49**

Joel Sternfeld

b. 1944 New York, New York, USA

Joel Sternfeld studied art
at Dartmouth College and
began taking photographs
in the 1970s, after becoming
interested in the color theory
of Bauhaus painter Johannes
Itten and photographer
Josef Albers. Sternfeld works
with a large-format view
camera, producing color
photographs that document
the banalities of place.
His publications include
American Prospects (1987),
*On This Site: Landscape in
Memoriam* (1997), *Stranger
Passing* (2001), and *When It
Changed* (2007).

» *McLean, Virginia* **p.161**

R
S

Alfred Stieglitz

b. 1864 Hoboken,
New Jersey, USA
d. 1946 New York, New York, USA

Born into a German-Jewish family, Alfred Stieglitz became both an important photographer and a significant writer on the medium. He became a coeditor of *The American Amateur Photographer* in 1893 and a member of the Linked Ring group of pictorialist photographers in 1894. In 1899 he held his first solo exhibition at New York's Camera Club. Stieglitz was responsible for the Photo Secession exhibition in 1902 and founded the influential journal *Camera Work*.

» *The Steerage* **p.33**

Sir Benjamin Stone

b. 1838 Birmingham, UK
d. 1914 Birmingham, UK

Sir John Benjamin Stone founded the National Photographic Record Association in 1895. A Member of Parliament, he traveled throughout Britain and to Brazil, Japan, Spain, and Norway, and recorded his journeys in photographs. His images were published in two volumes, in 1906, as *Festivals, Ceremonies and Customs* and *Parliamentary Scenes and Portraits*. Stone is credited as a major influence on British documentary photographers in the 1970s and 1980s.

» *The Players in the Abbots Bromley Horn Dance* **p.149**

Paul Strand

b. 1890 New York, New York, USA
d. 1976 Oregeval, France

Paul Strand studied photography under Lewis Hine at the Ethical Culture Fieldston School in New York. Influenced by pictorialism in the early years of his career, he later became one of the most influential modernists of his time, producing photographs of the United States that defined a nation and influenced generations of photographers. Strand was also an innovative documentary filmmaker, with credits including *The Plow That Broke the Plains* (1936) and *Native Land* (1942).

» *Wall Street* **p.21**

Josef Sudek

b. 1896 Kolín, Central Bohemian
Region, Czech Republic
d. 1976 Prague, Czech Republic

Josef Sudek studied photography at the State School of Graphic Arts from 1911 to 1913. Widely acknowledged as one of Czechoslovakia's most significant photographers, Sudek cofounded the Czech Photographic Society in 1926. His intimate still life photographs and meticulous documentation of his home city have been exhibited and published worldwide, at venues including the International Museum of Photography: George Eastman House (1974).

» *Plaster Head* **p.59**

Hiroshi Sugimoto

b. 1948 Tokyo, Japan

Hiroshi Sugimoto studied politics and sociology in Tokyo before enrolling at the Art Center College of Art and Design in Los Angeles. He settled in New York in 1974, and his first photographic series, *Dioramas* (1976–), evolved out of visits to the city's Museum of Natural History. The series *Theaters* commenced in 1979, and in 1980, Sugimoto embarked upon *Seascapes*. He has subsequently constructed numerous photo series, including *Chamber of Horrors* (1994) and *Pine Trees* (2001).

» *Baltic Sea, Rugen* **p.65**

Larry Sultan

b. 1946 Brooklyn, New York, USA
d. 2009 Greenbrae, California, USA

Larry Sultan grew up in Los Angeles and studied political science at the University of California at Santa Barbara before gaining a master's in fine art from the San Francisco Art Institute. He became known for coauthoring the book *Evidence* (1977), which contains photographs selected from industrial and government archives. Sultan continued his exploration into photography's fictions with a project on his retired parents, which he published as *Pictures From Home* (1992).

» *Conversation Through a Kitchen Window* **p.101**

Wolfgang Tillmans

b. 1968 Remscheid, North Rhine-Westphalia, Germany

Wolfgang Tillmans studied at the Bournemouth and Poole College of Art and Design. In the late 1980s he began taking photographs of the European club scene, which were published in style magazines such as *i-D*. Tillmans has used the snapshot aesthetic and a wide range of subject matter to produce bodies of work that incorporate the celebrated and the mundane, the personal and the public. In 2000 he became the first photographer to be awarded the Turner Prize.

» *Lutz and Alex Sitting in the Trees* **p.193**

Jeff Wall

b. 1946 Vancouver, British Columbia, Canada

Jeffrey Wall studied art at the University of British Columbia and London's Courtauld Institute. In the 1980s he was influential in the Vancouver School of postconceptual photography. He uses performers, costumes, and sets to create digital montages that appear to document real events, often mounted as transparencies on light boxes. He also manipulates multiple shots to make reinterpretations of classical paintings. He has exhibited and published widely and internationally.

S
T
U
V
W

» *Rainfilled Suitcase* **p.195**

Nick Waplington

b. 1965 London, UK

Nick Waplington studied art at Trent Polytechnic and completed postgraduate studies at the Royal College of Art in London. In 1987 he began a series documenting the life of two working-class families in Nottingham, which was published as *Living Room* in 1991. Since then he has produced a number of monographs, including *Other Eden* (1994), *Safety in Numbers* (1997), and *You Love Life* (2005). The latter features images of friends and lovers, and representations of banal details that make up daily life.

» From the series *Living Room* p.81

Gillian Wearing

b. 1963 Birmingham, UK

Gillian Wearing studied art at London's Chelsea School of Art and Goldsmiths College. In 1993 she exhibited her series *Signs That Say What You Want Them to Say and Not Signs That Say What Someone Else Wants You to Say* (1992–93) at London's City Racing Gallery; four years later she won the Turner Prize. In 2003 she used props, costumes, and prosthetic masks and posed as members of her family for her ongoing photographic series *Album* (1993–) based on family snapshots.

» *Self-Portrait as My Father Brian Wearing* p.91

Weegee

b. 1899 Lemberg, (now) Ukraine
d. 1968 New York, New York, USA

Weegee was born Usher Fellig in Austria, and immigrated to the United States in 1910. He is known for his incisive photographs of New York, and for his determination to be the first photographer at the scene of a crime or disaster. His solo exhibition "Weegee: Murder Is My Business" was shown at the Photo League in 1941, and his work was exhibited at New York's Museum of Modern Art in 1943 and 1944. His monograph *Naked City* (1945) is one of photography's great classics.

» *The Critic* p.155

William Wegman

b. 1943 Holyoke,
 Massachusetts, USA

William Wegman studied painting, photography, and video at Massachusetts College of Art and the University of Illinois at Urbana-Champaign. He began making photographs in the 1970s. He is known for his extensive and witty photographs and videos of dogs—predominantly his own Weimaraners—shown in various costumes, human clothes, and poses. He has exhibited internationally and his publications include *Man's Best Friend* (1982), *Fay* (1999), and *Funney/Strange* (2006).

» *Ray and Mrs. Lubner in Bed Watching TV* p.115

Edward Weston

b. 1886 Highland Park,
 Illinois, USA
d. 1958 Big Sur, California, USA

Edward Weston began his formal career in photography by working as a retoucher in a Los Angeles studio. In the early 1920s he began to make the elegant, modernist portraits and still life photographs on which his reputation now rests. After a period spent in Mexico, he returned to California, where in the mid-1920s he developed his personal photographic practice and cofounded the influential f64 group. A major retrospective was held in 1946 at New York's Museum of Modern Art.

» *Nautilus* **p.51**

Minor White

b. 1908 Minneapolis,
 Minnesota, USA
d. 1976 Boston, Massachusetts, USA

Minor White studied botany and English at the University of Minnesota. He worked for the Works Progress Administration before serving in the military during World War II. Postwar, White taught at California School of Fine Arts, Rochester Institute of Technology, and Massachusetts Institute of Technology. He was a cofounder and editor of *Aperture* magazine from 1952, and monographs include *Mirrors, Messages, Manifestations: Photographs and Writings 1938–1968* (1969).

» *Vicinity of Naples* **p.179**

Garry Winogrand

b. 1928 New York, New York, USA
d. 1984 Tijuana, Mexico

Garry Winogrand studied photojournalism at the New School for Social Research in New York. He went on to work as a freelance photojournalist for several magazines including *Life* and *Fortune*. His first book, *The Animals* (1969), typified the new US documentary photography, and he was included in the landmark exhibition "New Documents" at the Museum of Modern Art, New York, in 1967. Other publications include *Public Relations* (1967) and *Stock Photographs* (1980).

» From the series *The Animals* **p.157**

Donovan Wylie

b. 1971 Belfast, Northern Ireland

Donovan Wylie was born in Northern Ireland, and his first monograph, *32 Counties: Photographs of Ireland*, was published in 1989. He joined Magnum Photos in 1992. Wylie's work explores themes of religious identity, territory, conflict, and history. He has worked in China, Yugoslavia, Slovakia, and Israel, and his monographs include *The Maze* (2004) and *British Watchtowers* (2007). He has had solo exhibitions at the Photographers Gallery, London, and the National Media Museum, Bradford.

» *The Maze Prison, Sterile, Phase 1* **p.145**

W
X
Y
Z

TIMELINE

1900

The Players in the Abbots Bromley Horn Dance

The Flatiron

The Steerage

Textile Mill, USA

1910

Wall Street

1920

Circus, Budapest

Nautilus

Autoportrait

A Solarized Portrait of Lee Miller

Divers

Bricklayer

1930

A Monastic Brothel

Tic-Tac Men at Ascot Races

Migrant Family

Gertrude Stein and Alice B. Toklas

Interior of Coal Miner's Home

Looking at German Luftwaffe Pilots Flying Over the Gran Via

Martha Graham, Frontier

1940

Goya Fashion

The Critic

Dead SS Guard Floating in Canal

The Living Dead of Buchenwald

Plaster Head

Gestapo Informer

Homecoming Prisoners

Sand Dunes, Sunrise

Barn Owl

1950

From the series *Västerbotten*

Girl About to Do a Handstand

1960

Kathy Reflected in Cigarette Machine

Margot Fonteyn and Rudolf Nureyev

Straznice

Mutter Ridge

Soldiers With a Group of Captured Subjects

From the series The Animals

1970

Greenwood, Mississippi

One Minute Before British Paratrooper Fires

Chelsea Flower Show

The Brown Sisters

Youths Practice Throwing Contact Bombs

McLean, Virginia

County Down, Ireland

From the series The Teds

A House in Ireland

Single Stone, Ring of Brogar

Untitled Film Still, No. 3

Café Lehmitz

1980

Helena, Sloane Square

Ray and Mrs. Lubner in Bed Watching TV

Haus Nr. 9

From the series Living Room

Nan and Brian in Bed

From the series Beyond Caring

From the series Rich and Poor

From the series The Last Resort

Gold Mines of Serra Pelado

Conversation Through a Kitchen Window

The Landscape

1990

From the series Grapevine

Dresie and Casie, Twins

Kuivaniemi, Finland

From the series Faith

Kolobrzeg, Poland

From the series
The Banquet

Lutz and Alex Sitting in the Trees

From the series The Table of Power

From the series Set Constructions SO14

From the series Drum

Baltic Sea, Rugen

From the series Case History

2000

Former Teahouse in a Park

Rainfilled Suitcase

The Maze Prison, Sterile, Phase 1

Gdansk

Self-Portrait as My Father Brian Wearing

From the series 21st Century Types

Amor Omnia Vincit

Rayne-Lin, Little Miss Firecracker

WORK STORY BEAUTY RELATIONSHIPS THE EVERYDAY HOME CONFLICT THE UNEXPECTED MOVEMENT OUTSIDE

GALLERIES

**AMADOR GALLERY,
NEW YORK, USA**
amadorgallery.com

From the series *The Table of
Power* 1994 Jacqueline Hassink
≫ WORK

**BARBARA MORGAN ARCHIVE,
HASTINGS ON HUDSON,
NEW YORK, USA**

Martha Graham, Frontier 1935
Barbara Morgan
≫ MOVEMENT

**BENJAMIN STONE COLLECTION,
BIRMINGHAM ARCHIVES AND
HERITAGE, BIRMINGHAM, UK**
www.birmingham.gov.uk/
benjaminstone

*The Players in the Abbots Bromley
Horn Dance* c.1900
Sir Benjamin Stone
≫ THE UNEXPECTED

**CARTIN COLLECTION,
WADSWORTH ATHENEUM
MUSEUM OF ART,
CONNECTICUT, USA**
www.cartincollection.com

*Dresie and Casie, Twins,
Western Transvaal* 1993
Roger Ballen
≫ RELATIONSHIPS

**CECIL BEATON
STUDIO ARCHIVE**
www.sothebys.com

*Gertrude Stein and
Alice B. Toklas* 1936
Cecil Beaton
≫ RELATIONSHIPS

**DIE PHOTOGRAPHISCHE
SAMMLUNG/SK STIFTUNG
KULTUR, COLOGNE, GERMANY**
www.sk-kultur.de/photographie

Bricklayer 1928
August Sander
≫ WORK

**FRAENKEL GALLERY, SAN
FRANCISCO, CALIFORNIA, USA**
www.fraenkelgallery.com

Baltic Sea, Rugen
1996
Hiroshi Sugimoto
≫ BEAUTY

*The Brown Sisters,
New Canaan* 1975
Nicholas Nixon
≫ RELATIONSHIPS

**GALLERIA MARTINI & RONCHETTI,
GENOVA, ITALY**
www.martini-ronchetti.com

Autoportrait 1929
Florence Henri
≫ BEAUTY

**HORST ESTATE, MIAMI,
FLORIDA, USA**
www.horstphorst.com

Goya Fashion 1940
Horst P. Horst
≫ THE UNEXPECTED

**IRISH MUSEUM OF MODERN ART,
DUBLIN, IRELAND**
www.modernart.ie

County Down, Ireland 1978
Marc Riboud
≫ OUTSIDE

**J. PAUL GETTY MUSEUM,
LOS ANGELES, CALIFORNIA, USA**
www.getty.edu/museum

Greenwood, Mississippi 1973
William Eggleston
≫ THE EVERYDAY

*Mutter Ridge, Nui Cay Tri,
South Vietnam* 1966
Larry Burrows
≫ CONFLICT

The Critic 1943
Weegee
≫ THE UNEXPECTED

LEE MILLER ARCHIVE
www.leemiller.co.uk

*Dead SS Guard Floating
in Canal, Dachau* 1945
Lee Miller
≫ CONFLICT

**LIBRARY OF CONGRESS,
WASHINGTON, D.C., USA**
catalog.loc.gov

Migrant Family 1936
Dorothea Lange
≫ STORY

Textile Mill, USA 1908
Lewis Hine
≫ WORK

**METROPOLITAN MUSEUM
OF ART, NEW YORK, USA**
www.metmuseum.org

*Interior of Coal Miner's Home,
West Virginia* 1935
Walker Evans
≫ HOME

Kolobrzeg, Poland 1992
Rineke Dijkstra
≫ OUTSIDE

*Nan and Brian
in Bed* 1983
Nan Goldin
≫ STORY

The Flatiron 1904
Edward Steichen
≫ BEAUTY

**MINOR WHITE ARCHIVE,
PRINCETON UNIVERSITY,
NEW JERSEY, USA**
artmuseum.princeton.edu

Vicinity of Naples 1955
Minor White
≫ OUTSIDE

**MUSEUM OF CONTEMPORARY
PHOTOGRAPHY, CHICAGO,
ILLINOIS, USA**
www.mocp.org

*Conversation Through
a Kitchen Window* 1986
Larry Sultan
≫ THE EVERYDAY

"Kathy Reflected in Cigarette Machine," from the series *Brooklyn Gang* 1959
Bruce Davidson
⏩ CONFLICT

One Minute Before British Paratrooper Fires, Bloody Sunday, Derry, Northern Ireland 1972 **Gilles Peress**
⏩ CONFLICT

MUSEUM OF MODERN ART, NEW YORK, USA
www.moma.org

A Solarized Portrait of Lee Miller 1929
Man Ray
⏩ BEAUTY

McLean, Virginia 1978
Joel Sternfeld
⏩ THE UNEXPECTED

Nautilus 1927
Edward Weston
⏩ BEAUTY

"Straznice," from the series *Gypsies* 1965
Josef Koudelka
⏩ OUTSIDE

The Landscape 1988
Tina Barney
⏩ RELATIONSHIPS

Tic-Tac Men at Ascot Races 1935
Bill Brandt
⏩ WORK

Untitled Film Still, No. 3 1977
Cindy Sherman
⏩ STORY

NATIONAL MEDIA MUSEUM, BRADFORD, UK
www.nationalmediamuseum.org.uk

Former Teahouse in a Park, Kabul 2001–02 **Simon Norfolk**
⏩ CONFLICT

Gestapo Informer, Dessau, Germany 1945
Henri Cartier-Bresson
⏩ RELATIONSHIPS

Single Stone, Ring of Brogar, Orkney 1979
Fay Godwin
⏩ OUTSIDE

NILS STAERK CONTEMPORARY ART, COPENHAGEN, DENMARK
www.nilsstaerk.dk

From the series *Set Constructions SO14* 1995–2000
Miriam Bäckström
⏩ HOME

PACE/MACGILL GALLERY, NEW YORK, USA
www.pacemacgill.com

Ray and Mrs. Lubner in Bed Watching TV 1981
William Wegman
⏩ HOME

SAN FRANCISCO MUSEUM OF MODERN ART, CALIFORNIA, USA
www.sfmoma.org

Plaster Head 1945
Josef Sudek
⏩ BEAUTY

Wall Street 1915
Paul Strand
⏩ WORK

Youths Practice Throwing Contact Bombs in Forest Surrounding Monimbo c.1978
Susan Meiselas
⏩ CONFLICT

STALEY-WISE GALLERY, NEW YORK, USA
www.staleywise.com

Divers 1930
George Hoyningen-Huene
⏩ BEAUTY

STEPHEN BULGER GALLERY, TORONTO, CANADA
www.bulgergallery.com

Circus, Budapest 1920
André Kertêsz
⏩ STORY

STEVEN KASHER GALLERY, NEW YORK, USA
stevenkasher.com

Soldiers With a Group of Captured Subjects, Quin Hon, South Vietnam 1967
Philip Jones Griffiths
⏩ CONFLICT

TIME & LIFE ARCHIVE
www.timelifepictures.com

The Living Dead of Buchenwald 1945
Margaret Bourke-White
⏩ CONFLICT

VÄSTERBOTTEN MUSEUM, UMEÅ, SWEDEN
www.vbm.se

From the series *Västerbotten* 1950s–60s
Sune Jonsson
⏩ HOME

VICTORIA & ALBERT MUSEUM, LONDON, UK
www.vam.ac.uk

From the series *The Last Resort* 1986
Martin Parr
⏩ THE EVERYDAY

"Girl About to Do a Handstand," from the series *Southam Street* 1957
Roger Mayne
⏩ MOVEMENT

Lutz and Alex Sitting in the Trees 1992
Wolfgang Tillmans
⏩ OUTSIDE

WHITNEY MUSEUM OF AMERICAN ART, NEW YORK, USA
whitney.org

The Steerage 1907
Alfred Stieglitz
⏩ STORY

INDEX

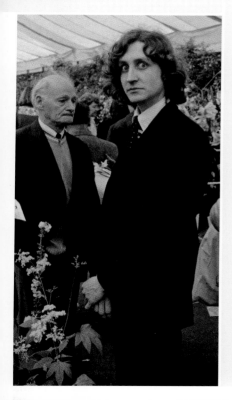